POSTCARD HISTORY SERIES

East Orange

IN VINTAGE POSTCARDS

POSTCARD HISTORY SERIES

East Orange

IN VINTAGE POSTCARDS

Bill Hart

ARCADIA

Published by Arcadia Publishing,
an imprint of Tempus Publishing, Inc.
2 Cumberland Street
Charleston, SC 29401

Printed in Great Britain.

Library of Congress Catalog Card Number: 00-103560

For all general information contact Arcadia Publishing at:
Telephone 843-853-2070
Fax 843-853-0044
E-Mail sales@arcadiapublishing.com

For customer service and orders:
Toll-Free 1-888-313-2665

Visit us on the internet at http://www.arcadiapublishing.com

*To my wife, Andrea, whose love,
encouragement, and belief in me
made this book possible.*

CONTENTS

ACKNOWLEDGMENTS

My first thanks go to my wife, Andrea Alam Hart. Andrea was a "research widow" for the 14 months that I worked on this book. She assisted me in the selection of postcards and supplied me with her own invaluable recollections of East Orange. Her love and support were incalculable.

Next, I would like to thank my old "69 Warrington Place" friend Andy Fedors. Andy was my driver for the half-dozen weekends on which we re-photographed all of the scenes found in this book. My thanks also to his wife, Maurica Colbert Fedors, the other "research widow" in this story, for her understanding.

Third, I wish to thank J. Robert Starkey from the Reference Department of the East Orange Public Library. He made available to me all of the files, maps, and photographs at his disposal. I would not have been able to complete this book without his assistance.

I would also like to thank Virginia (Jinny) Baeckler, director of the Plainsboro Public Library; Savanah Jackson Mapelli, attorney; Regan Naticchia, reference librarian at the Plainsboro Public Library; the staff of the East Orange Public Library, particularly Sally Rice, Aleyamma Mathai, Barbara Fay, and Ivonne Kratz; Dominick D'Altilio, assistant director of East Orange Public Works; Dorothy S. Jones, former director of the East Orange Public Library; Curtis Carlough, New Jersey Midland Railroad Historical Society; Tom McConkey, New Jersey Midland Railroad Historical Society; Kathy Do, Berkeley College; Larry Luing, chair of the Berkeley College Board of Trustees; Kevin Coyne, author; Mary Therese Hankinson, Veteran's Administration Hospital; Lucius A. Bowser, East Orange Historical Society; Leland Michael, Black United Fund of New Jersey; Carol Marlowe, reference librarian at the Rahway Public Library; Kathleen M. Ballard, Christ Church; the Plainsboro Literary Group, especially Marvin Cheiten, Jack Cohen, Alan Grayson, Hilary Kayle, Ed Leefeldt and Kathy Meeker; Don Dorflinger, co-author of *Orange: A Postcard Guide to Its Past*; Charles F. Cummings, the Newark Public Library; Thomas T. Taber III; Donald Van Court; John W. Edelen; Joyce Walker; Steve Cohen; Peter Turco, my editor at Arcadia Publishing; and Vincent Forgione, who gave me my love of writing at Essex Catholic High School.

My thanks also go to my sister, Kathleen Hart, for her recollections of Our Lady of All Souls (OLAS), and to my old "151 Park Avenue" friend Larry Kelly, for his recall on the films of James Cagney. Finally, I would like to thank my parents, William S. Hart and Joan Dougher Hart, for having the good sense to move to East Orange, as well as for their recollections. I thank them also for their love, support, and the sacrifices they made for me.

INTRODUCTION

When Lucy Ricardo made a U-turn in the Holland Tunnel, the policeman told her that "the cars were backed up all the way to East Orange, New Jersey." When Dizzy Davis (James Cagney) was dating a "slim brunette" in *Ceiling Zero*, she "lived in a little white house over in East Orange." Naturalist John Burroughs, author Zane Grey, nurse Clara L. Maass, Adm. Raymond A. Spruance, Rear Adm. Frederick W. Pennoyer Jr., actress Ann Harding, actor Gordon McRae, author W.E.B. Griffin, singer Dionne Warwick, singer Whitney Houston, and entertainer Queen Latifah all were born or lived in East Orange.

Why did the most popular television comedy of all time, *I Love Lucy*, mention East Orange in multiple episodes? Why would a writer for a James Cagney film refer to East Orange in the script? Was East Orange that popular? Yes! As early as 1896, author Henry Whittemore referred to East Orange as "the richest and, in many respects, the most important [township] in the state." In 1945, East Orange was rated the 20th best place to live in the country for cities having over 30,000 residents. The Prudential Insurance Company reported in 1950 that East Orange had the ninth highest average family income in the nation. East Orange was named the "Cleanest City in the Nation" three times before its 100th anniversary.

East Orange would never have been written if my wife, Andrea, and I did not like to visit antique shops. It was on such an excursion that I discovered my first postcard of East Orange. We were in a shop in Lambertville when I noticed several boxes of old postcards. I pulled down a box marked New Jersey and flipped to the letter E. There were about 20 old views of East Orange. The first one I saw was of Essex County Boulevard. Essex County Boulevard? I had never heard of it. With that discovery, I was hooked.

I have since learned that postcard collecting is one of the most popular hobbies in America. The golden age of postcards lasted from about 1900 to 1918. At that time, postcards were used much as greeting cards are used today. In an era when few people owned telephones, postcards were also an inexpensive, speedy way to send a message, especially in a time when many towns had two mail deliveries per day. Postcard companies photographed virtually every scene possible in the towns and cities across the United States. East Orange was no exception. My personal collection includes over 500 different postcards of East Orange. I believe it is possible that as many as 1,000 more views of East Orange are still out there waiting to be found.

Occasionally you will see writing on the front of some of the postcards in this book. Only addresses were allowed on the back of a postcard before March 1, 1907. Sometimes, the printer left a space on the front of the postcard for messages. Starting around 1915, postcards were

printed with borders. At about that same time greeting cards, tariffs, and telephones sent postcard usage into a decline. Since dating postcards is somewhat uncertain, I did not always include an estimated age in the caption. However, I believe that the reader will be able to assess the time period from the information provided above, the dress of the people, the type of pavement, and the types of vehicles in the images.

East Orange is a pictorial history of the city and a snapshot of a bygone era in America. The postcards tell the story of East Orange from its incorporation as a city in 1899 to her 100th anniversary as a separate entity in 1963. The emphasis, however, is on the years between 1900 and 1918. Through these postcards, the reader can view life as it was experienced during that period. Text has been added to tell the story that the images cannot. I have endeavored to make that text as factual as possible. To do so, I consulted dozens of books, articles, photographs, and maps. Unfortunately, the facts in those documents sometimes conflicted. When that occurred, I tried to find a corroborating source. Failing that, I used what I believed to be the most reliable document, based on the author, purpose, date, and whether the source was primary or secondary. Even then, I was not always certain as to what was correct. That is why you will sometimes see the words "probably" or "most likely" used in the captions. While I had help on this book from some very knowledgeable people, any errors in the text are mine, not theirs.

This is a book of what *was*, not what *is*. Therefore, and since space was limited, I did not always report if the building is still there, nor did I state if it has been renamed. I would estimate, however, that about half of the scenes depicted in this book still look very much the same today. Most of the buildings and homes are still in use.

This writing has been a labor of love. East Orange was my hometown. Many of my family's roots are in the city. My mother, Joan Dougher Hart, came to East Orange from Archbald, Pennsylvania, in 1943. My father, William S. Hart, came from that same small town in 1950. I was born in Newark, but lived first on North Munn Avenue and then on Warrington Place. I attended Our Lady of All Souls Grammar School from kindergarten through eighth grade. My first job was in East Orange at City Federal Savings & Loan Association on North Eighteenth Street. My three sisters were born in the East Orange General Hospital. They graduated from OLAS and East Orange Catholic High School. My wife, Andrea, lived in East Orange until she was nine years old, attending Our Lady Help of Christians. She also graduated from East Orange Catholic High School.

There are 200 postcards in this book. Sixteen photographs have been used for scenes where postcards were not available. I have tried to create a comprehensive view of the city. Unfortunately, it was not possible to show every school, church, or street. I hope I have succeeded, however, in producing at least one pleasant memory for every reader of this book.

I sincerely wish that you enjoy reading *East Orange* much as I enjoyed writing it.

One
HISTORY

In May 1666, 30 Puritan families under the leadership of Robert Treat left Milford, New Haven, to found a new town on the Pesayak (Passaic) River. The Puritans were seeking to continue their theocratic form of government. The New Haven and Connecticut colonies were merging, and the theocracy the Puritans had known there was no longer guaranteed.

The Duke of York had only recently deeded New Jersey to Sir George Carteret and Sir John Berkeley. Carteret was granted the northern portion of the area, and so it was with him that the Puritans negotiated terms. For the "quit-rent of a half-penny per acre per annum," the Puritans obtained land that spread from the Pesayak River on the north to the Weequahic Creek on the south and from the bay on the east to the foot of the (Orange) mountain.

Although Governor Carteret had agreed to purchase the land from the Hackensack band, Unami division of the Delaware (or Leni Lenape) tribe, the deal had not been made when the settlers arrived. The Native Americans were irate, but Carteret arrived in time to negotiate the dispute before the settlers could pack and return to Milford. The land was purchased for "four barrels of beere, two ankors of liquor, fifty double hands of powder, one hundred barrs of lead, ten swords, twenty axes, twenty coates, ten guns, twenty pistols, ten kettles, four blankets, ten pair breeches, fifty knives, twenty howes [hoes], 850 fathoms of wampum, and three troopers' coates."

The government decided upon by these settlers was outlined in a document called the Fundamental Agreement. Adopted on May 21, 1666, the document proclaimed that only members of a congregational church could be classified as freemen. Thus, only church members could vote or hold office, but all others could own property and enjoy civil liberties. The settlement was named Newark in honor of Rev. Abraham Pierson, who had received his ministerial orders at Newark-on-Trent, England.

Almost immediately, the colonists began to move west, using that land for pasture and to quarry stone. In 1678, an additional purchase was made, and the holdings were extended to the top of the mountain. Settlers from England and Scotland immigrated to the mountain area. These people came to be known as the Mountain Society, but were still part of the Newark settlement. Everyone was required to attend the town meetings, so a series of crude roads developed between the mountain area and Newark. These first roads followed old Native American trails.

The Mountain Society wanted its own meetinghouse, and in 1720 one was erected on what would become Main Street in Orange. Around 1757, Rev. Caleb Smith referred in writing to the area as "Orange," perhaps after Prince William of Orange. The American Revolution seemed to fuel this desire to separate. On June 7, 1780, the name Newark Mountain was officially changed to Orange. Finally, on November 27, 1806, Orange was incorporated as a separate township. The new entity encompassed much of what today is known as Orange, East Orange, South Orange, and West Orange.

Perhaps it was the many discussions regarding state's rights before the Civil War that planted the seeds of insurrection within the town of Orange. Whatever the cause, South Orange was created on January 26, 1861, having been a part of Clinton (South Orange and Millburn) since 1835. Fairmount (comprised of parts of West Orange, Caldwell, and Livingston) separated on March 11, 1862. By January of 1863, there was serious talk of the First Ward (East Orange) breaking away. While Orange had not protested loudly the departure of South Orange or Fairmount, the treason of East Orange was hotly protested and debated. However, on March 4, 1863, East Orange became a separate township.

The citizens of East Orange did not separate from their mother township without what they considered just cause. The Orange township committee wished to incorporate and raise taxes to create fire and police departments, pave roads, and erect street lamps. East Orange, made up mostly of farms, did not see the need for such expenditures. Likewise, Orange did not fight the separation of East Orange merely over principle. East Orange, the first ward, was the wealthiest ward. Its loss would seriously affect the expenditures planned by the Orange township committee.

The newly formed township consisted of about 2,400 acres, or just less than 4 square miles. There were about 3,000 residents. William King was chosen the first chairman on April 16, 1863. Joseph L. Munn was elected clerk and Amzi Dodd was selected as township counsel. The first budget was fixed at $8,488.60. The ratables were determined to be $1,042,350. The town had three school districts: Ashland, Franklin, and Eastern.

East Orange grew quickly. The improvements that the citizenry had thought frivolous were started. By the early 1870s, roads were being macadamized and lit with gas lamps. The population broke 4,000. New streets were opened. Houses were built. Plank sidewalks were laid down. The location, transportation, utilities, government, and beauty of the town were attracting people from many areas. Trolley and train lines made East Orange only a short ride away from Newark and New York. By 1900, the population had grown to 30,000. The township form of government was no longer effective. On December 9, 1899, East Orange incorporated as a city. Edward E. Bruen was sworn in as the first mayor.

By 1920, East Orange had a population of almost 40,000. Residential houses gave way to apartment buildings as developers, running out of land, had no choice but to "go up." Retail stores lined Main Street and Central Avenue. Sixty-eight thousand people lived in East Orange in 1930. The Depression slowed growth a bit, but by the 75th anniversary celebration in 1938, more than 70,000 people called East Orange home. By the time East Orange turned 100, the Garden State Parkway had already bisected the city, and the population was over 80,000.

The little village was all grown up.

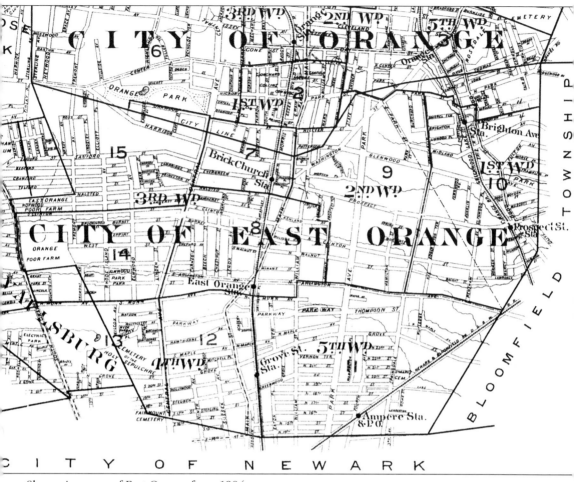

Shown is a map of East Orange from 1904.

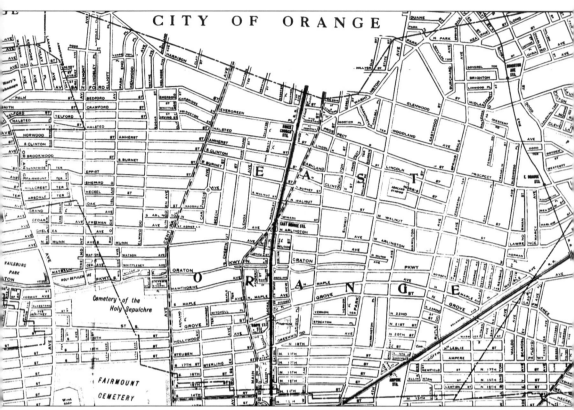

Pictured is a 1938 map of East Orange.

Two
TRANSPORTATION

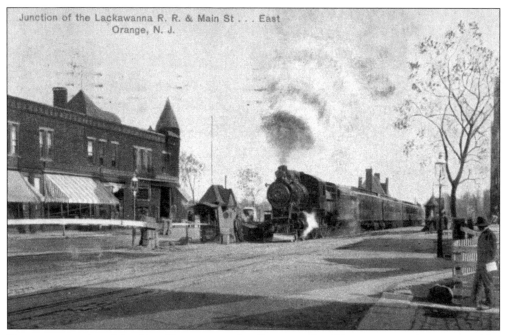

Junction of the Lackawanna R. R. & Main St . . . East Orange, N. J.

The success enjoyed by East Orange was the direct result of its transportation system. The Delaware, Lackawanna, & Western Railroad (DL&W), along with the Erie Railroad, constructed three train lines and six stations in the city. There were also three trolley lines. Today, only two railroad stations remain, and the trolleys are long gone. However, the Garden State Parkway and Route 280 have taken their place, connecting East Orange with points across the state and across the nation. This *c.* 1905 postcard depicts a westbound train pulling out of the East Orange Station. Main Street crosses from left to right, and Arlington Avenue crosses between the engine and first car. The building on the right is the Commonwealth Building.

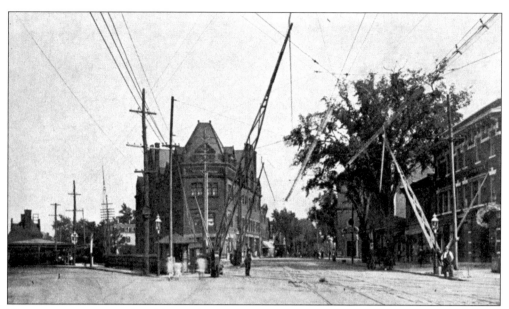

The Morris & Essex Railroad began horse-drawn rail service between Orange and Newark on November 19, 1836. Within two years, steam engines had replaced the horses. The Morris & Essex Railroad was eventually purchased by the Delaware, Lackawanna, & Western Railroad. This view looks east down Main Street. The East Orange Station is on the far left. The Commonwealth Building is in the center. The building with the doorway pillars is the Essex County Trust Company.

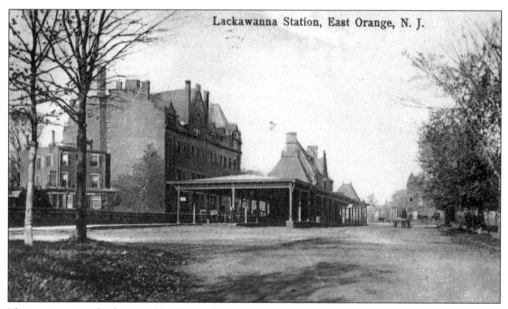

This station was built in 1883. Originally called the Junction, the name was changed to East Orange Station in the 1890s. This view looks west. To the left of the station, the north side of the Commonwealth Building is visible. The entrance to the East Orange Post Office was here. To the right of the station is Arlington Place. North Arlington Avenue crosses in front of the distant building on the far right.

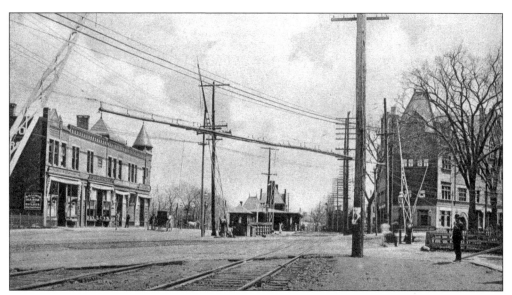

This view of the East Orange Station looks east. The station is in the center. Main Street crosses diagonally from left to right. On the right is the Commonwealth Building. Arlington Avenue crosses just in front of the horse-drawn carriage on the left. The white horse is standing on Arlington Place, later renamed City Hall Plaza. The land and house (barely visible) behind the horse were owned by Frederick M. Shepard.

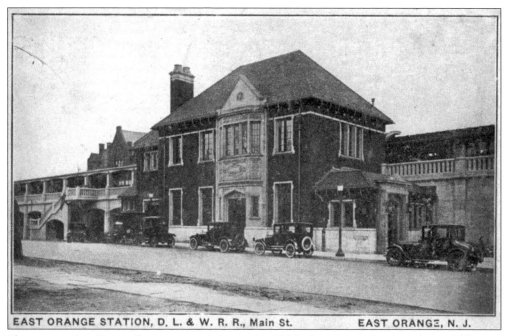

EAST ORANGE STATION, D. L. & W. R. R., Main St. EAST ORANGE, N. J.

The present East Orange Station was constructed in 1922 when the tracks were elevated. The city had wanted the tracks to be depressed. The DL&W favored elevation and wished to consolidate the number of East Orange Stations. East Orange residents were defeated on the track depression, but kept all four stations. Clara L. Maass, who died testing a yellow fever inoculation, lived in a house once located to the right of the building.

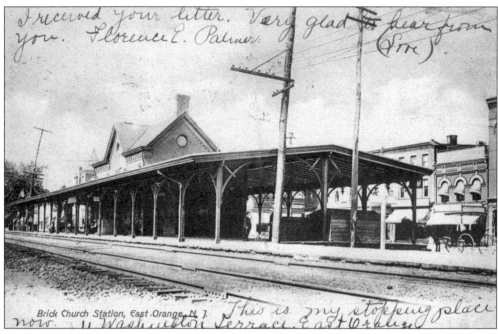

Brick Church Station, East Orange, N. J.

The first Brick Church Station was constructed in 1864 by Matthias Ogden Halsted. Halsted then donated the station to the Morris & Essex Railroad. This station remained in use until December 1, 1880, when the station shown above was built. This view looks west. The building partly visible on the right is the Essex Hotel. The spire in the distance is Trinity Congregational church on Harrison Street.

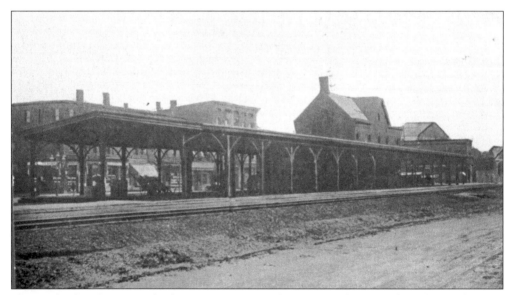

The Brick Church Station, built in 1880, remained in use until 1922, when the tracks were elevated and a new station was constructed. Full elevation was completed on December 17, 1922. The line was electrified on September 22, 1930. Thomas Edison was a passenger on the first electrified train. This view looks east. The large building to the left of the station is the Essex Hotel, located on the corner of Railroad and Prospect Place.

16

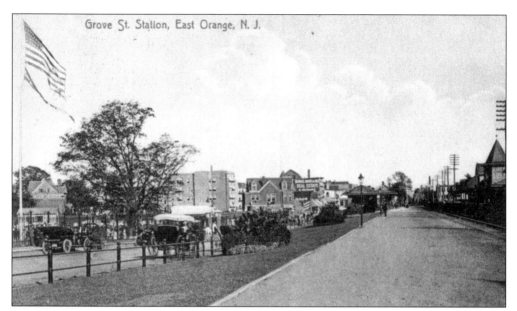

The Grove Street Station was originally called the East Orange Station, but the name was changed in the 1890s. The two station buildings shown were constructed in 1901 and opened on July 6, 1903. When the tracks were elevated in 1922, a second floor was added to the eastbound station. The road on the left is Eaton Place, and the flag is flying in Oval Playground. The Grove Street Station is no longer in use and has been torn down.

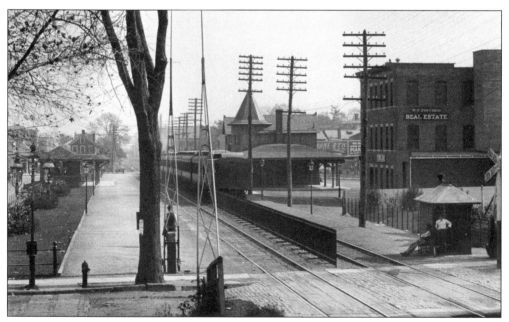

Shown is the same eastbound view a few years later. The cross street in the lower portion of the photograph is North Grove Street. The house just beyond the westbound station is on Greenwood Avenue. The street on the left is Eaton Place. Grade crossings were clearly dangerous. The railroad crossing sign on the right reads, "Look out for the locomotives." (Courtesy of the East Orange Public Library.)

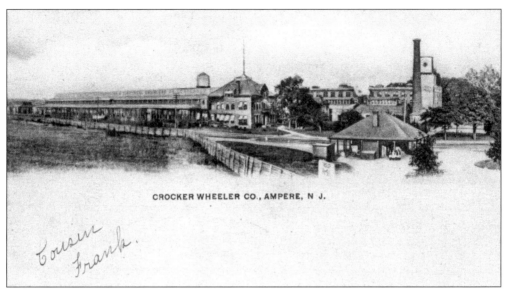

CROCKER WHEELER CO., AMPERE, N J.

The Montclair Branch (once called the Newark and Bloomfield) of the DL&W Railroad began running through East Orange on July 1, 1856. East Orange was then only a "flag stop" (an unscheduled stop) called "the Crescent." In 1893, the arrival of the Crocker-Wheeler Company, a manufacturer of electric motors, led to the development of the entire area. Crocker-Wheeler convinced the DL&W to build a small field stone station, seen in the right foreground.

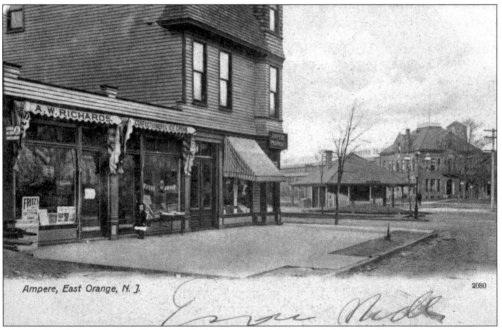

Ampere, East Orange, N. J. 2080

Dr. Schuyler S. Wheeler named the Ampere station, shown here in a closer view, after the famous French physicist Andre-Marie Ampere. This view looks east down Fourth Avenue near North Seventeenth Street. The Crocker-Wheeler factory is behind the station. The pharmacy sign indicates that the name Ampere was already being used in the section. Arthur Williamson Richards' Confectionery was the first store established in the Ampere Section.

18

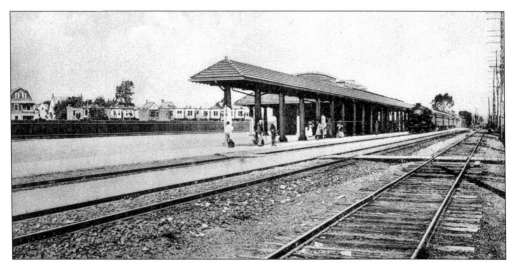

The second Ampere Station was built in 1908 and was used until the tracks were elevated in 1922. Crocker-Wheeler is out of view on the right. The houses on the left are on North Eighteenth Street. The train in the photograph is headed southbound. The Ampere Station is no longer in use and has been torn down.

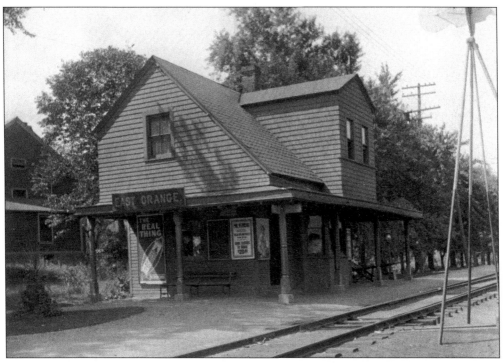

The Orange Branch (once called the Watchung) of the Erie Railroad's Greenwood Lake Division began passenger service through the Doddtown section of East Orange on July 10, 1876, eventually connecting West Orange to Jersey City. Built in the early 1890s, the East Orange Station was originally located at Glenwood Avenue, but it was later moved to the south side of the tracks just west of Prospect Street. Living quarters were provided above the station for the agent. (Courtesy of the New Jersey Midland RR Historical Society Collection.)

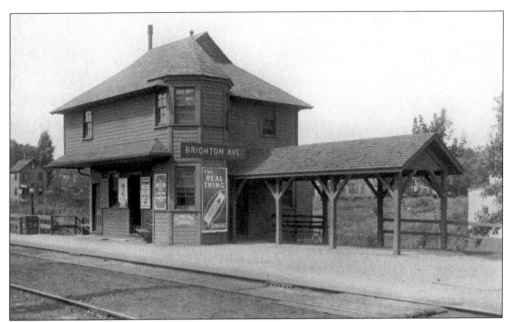

The Brighton Avenue Station was located on the north side of the track just west of Brighton Avenue. The Erie was a single-track line with passing tracks between Midland Avenue and North Park Street. Built in the early 1890s, living quarters were provided on the second floor. Both Erie stations were torn down in 1946. The line continuously lost money, and the last passenger run occurred on May 20, 1955. (Courtesy of the New Jersey Midland RR Historical Society Collection.)

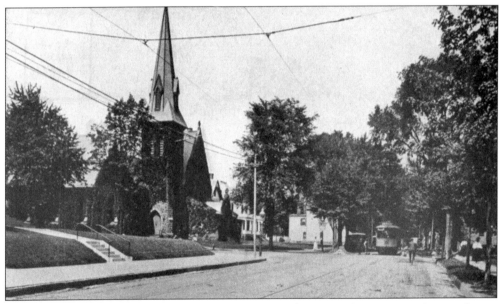

The Orange (Trolley) Line ran from Newark to Orange along Main Street. Beginning as a horse-drawn system, the first track was laid in April 1862, and the first run was made on June 5 of that year. A second track was laid in November 1869. This view looks west on Main Street. The stairs on the left lead to the Carnegie Library. The building on the left is the Munn Avenue Presbyterian Church, and the cross street is South Munn Avenue.

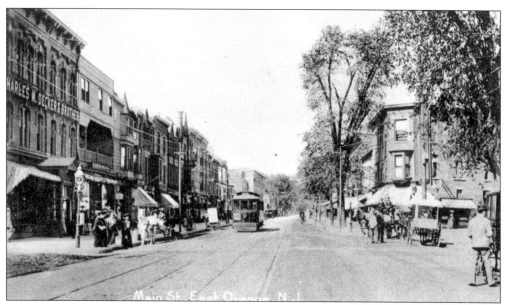

Much to the chagrin of Newark and Orange, East Orange did not allow Sunday service on the Orange Line until April 13, 1873. Opponents called it a question of whether or not to "desecrate the Sabbath." The Orange Line was electrified on January 27, 1892, and ran continuously until it was replaced by buses on March 1, 1951. This view looks west on Main Street. The street on the right is Washington Street. On the left is Charles M. Decker & Brothers, a grocer.

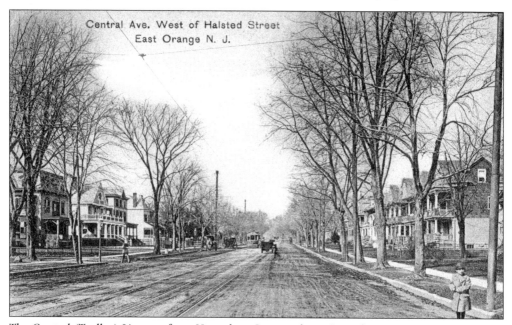

The Central (Trolley) Line ran from Newark to Orange along Central Avenue. Started in Newark in 1890, service ended at the East Orange border until it was extended to Orange on November 24, 1904. Before the trolleys came, Central Avenue was lined with large estates. The trolleys eventually brought stores, apartments, and middle-class housing. The man crossing the street on the left is at the Princeton Street intersection.

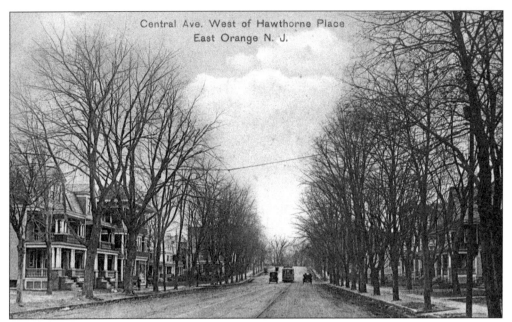

Central Ave. West of Hawthorne Place
East Orange N. J.

The fight to run trolleys along Central Avenue in East Orange was viciously disputed. Opponents formed the Citizen's Union and used every legal means available to stop construction, even appealing decisions to the New Jersey Supreme Court. These actions were defeated, but the Citizen's Union vowed revenge against the city council. They eventually succeeded in electing the first non-Republican mayor, Julian A. Gregory. This photograph was taken just west of the Cemetery of the Holy Sepulchre.

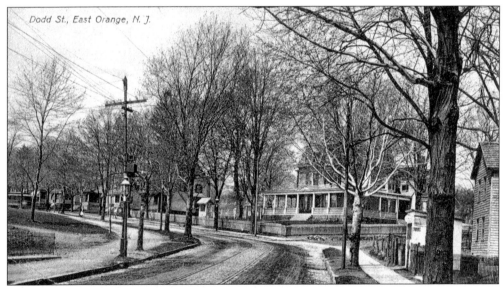

Dodd St., East Orange, N. J.

The Crosstown (Trolley) Line ran from Orange to Bloomfield beginning on June 7, 1888. It traveled along Dodd Street to Prospect Street, then turned north. It was a single line track with passing tracks located west of Midland Avenue and south of the Bloomfield line. This scene looks west on Dodd Street from Glenwood Avenue. The street on the right is Fulton Avenue (later Colonial Terrace). The trolley can be seen at the extreme left.

Three
MUNICIPAL BUILDINGS

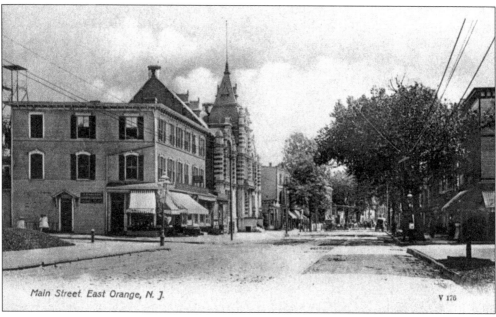

Main Street, East Orange, N. J. V 176

When East Orange separated from Orange in 1863, it had no public facilities and only $121 in its treasury. By the turn of the century, however, East Orange had "grown up" and included a municipal center, a library, a post office, a police department, and a fire department. This *c.* 1905 postcard looks east down Main Street. The building that looks like a gingerbread castle is the city hall, located between North Walnut Street (the cross street) and Winans Street. The building on the left housed John English, a caterer and baker of local renown. Behind the city hall is the bell tower, constructed in 1885 for use by the fire department. The police station (hidden) was directly behind the municipal building and in front of the tower.

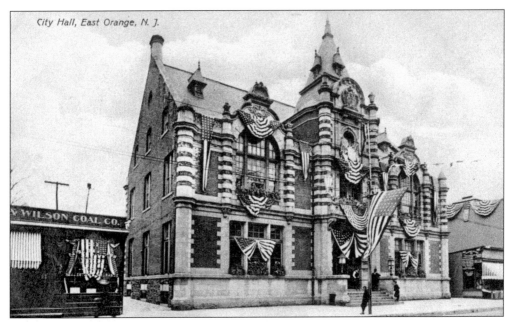

City Hall, East Orange, N. J.

The city took up business in this building, constructed at a cost of $29,000 on December 11, 1899. Prior to that, the town committee and police department had shared a brick building constructed in 1892 and located directly behind this one. After 1899, the police department became the sole occupant. To the left is the Fairlee & Wilson Coal Company. To the right is City Hall Fruit and Vegetable Market. This stretch of Main Street was nicknamed "the Promise Land."

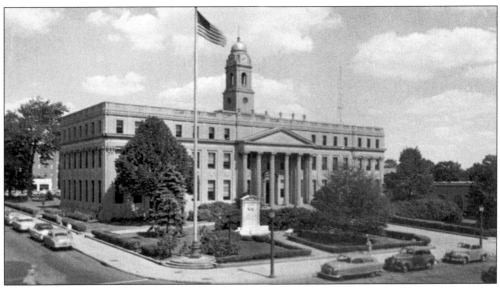

The new (and current) city hall, located on Arlington Place (now City Hall Plaza) between North Arlington Avenue and North Munn Avenue, was dedicated on September 21, 1929. A new police station (located on North Munn Avenue) and Health Department building (located on New Street) were constructed at the same time. Completing the civic square was the new post office that had opened several months earlier, constructed on the corner of North Munn Avenue and Arlington Place.

The Commonwealth Building, fronting on North Arlington Avenue and bordered by Arlington Place and Main Street, was built in 1887 by the Orange Water Company. The water company included a hall where public meetings could take place. The building was later bought by the East Orange Safe Deposit & Trust Company. The Commonwealth Building housed several businesses. The Orange Water Company, the East Orange National Bank, S&J Davis (a restaurant), and the East Orange Post Office all made their homes there at one time or another.

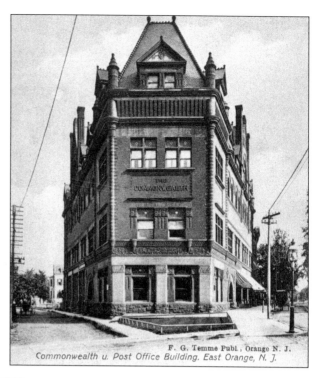

F. G. Temme Publ., Orange N. J.
Commonwealth u. Post Office Building. East Orange, N. J.

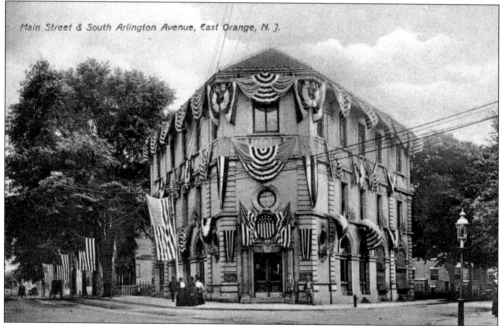

Main Street & South Arlington Avenue, East Orange, N. J.

While not a municipal building, the Essex County Trust Company building—constructed in 1896 across from the Commonwealth Building on Main Street and Arlington Avenue—also housed the Republican Club. Since East Orange was strictly a Republican town until Mayor Gregory was elected in 1910, the Republican Club and city council were mostly the same. This building also housed the Hope Lodge.

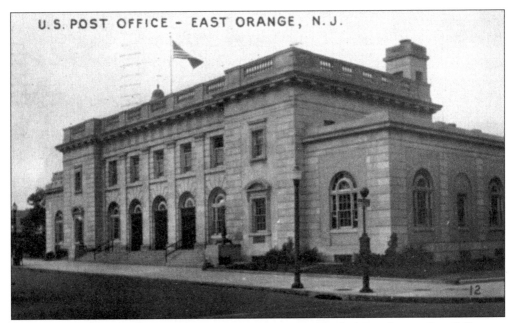

This East Orange Post Office building was opened in 1929. The first East Orange Post Office was opened February 15, 1869, in the Junction Train Station. The stationmaster, Isaac C. Beach, was the first postmaster. Substations were later opened in Brick Church, in Doddtown, and at Grove and Main Streets. The main post office was moved to the Doan Building, located on the northwest corner of Arlington Avenue and Main Street, by postmaster Mary E. Simonson in 1886.

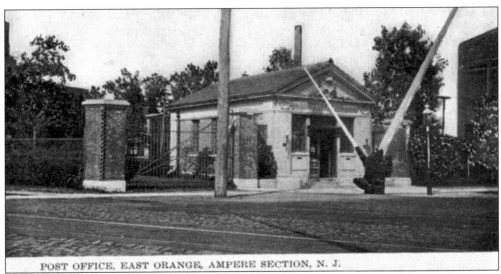

POST OFFICE, EAST ORANGE, AMPERE SECTION, N. J.

In January 1887, East Orange adopted a house numbering system. On July 1, 1887, a carrier system was started, closing the substations. That same year, the post office moved to the Commonwealth Building. The Ampere Post Office was requested by the Crocker-Wheeler Company and constructed c. 1895. It was located on Fourth Avenue just below North Sixteenth Street. Although built for Crocker-Wheeler use, the post office served the Ampere community.

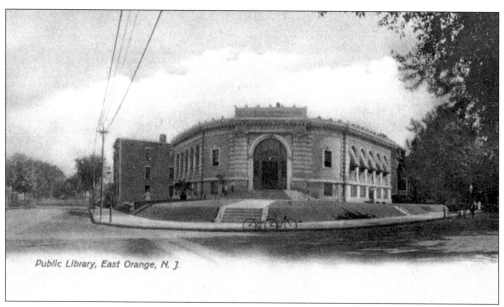

At the turn of the century, Alexander King, an East Orange resident and boyhood friend of Andrew Carnegie, convinced the steel magnate to donate $50,000 toward the construction of a library. The city purchased a lot at the corner of Main Street (left) and South Munn Avenue (right), and on January 22, 1903, the new library opened. The apartment building on the left was called "the Pring."

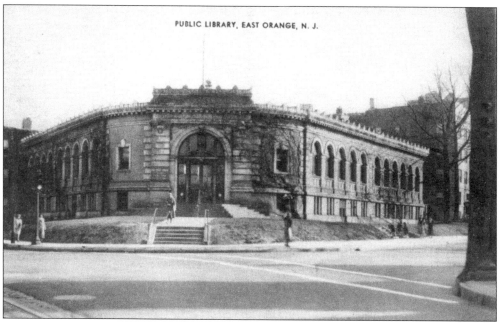

PUBLIC LIBRARY, EAST ORANGE, N. J.

The Carnegie Library Fund granted another $40,000 in 1914 for a much needed addition. The expanded building opened in 1915 with more than double the space. You can see that more windows have been added to each side of the building. The designer of the building was Hobart A. Walker. This building still stands but is now used as the municipal court.

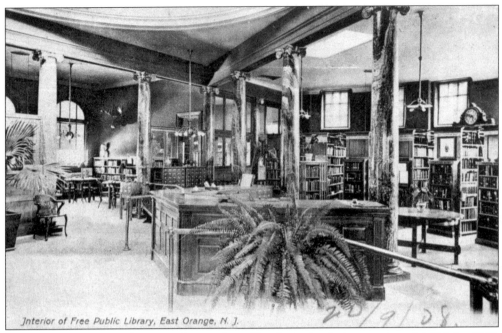

Interior of Free Public Library, East Orange, N. J.

When the library opened in 1903, the number of books in circulation numbered 9,000. By 1920, the number had increased to over 60,000. The first librarian was Sarah Slater Oddie. The president of the board of trustees was Frederick M. Shepard. Also on the board was Judge John Franklin Fort, who was elected governor of New Jersey in 1907.

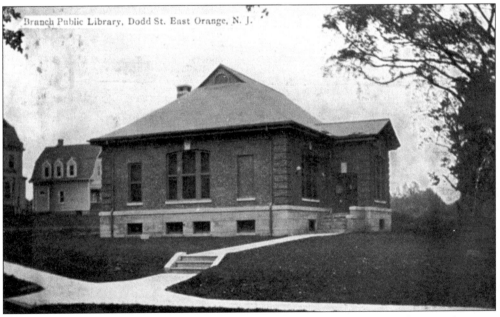

Branch Public Library, Dodd St. East Orange, N. J.

The Franklin Branch of the Carnegie Library was built after the city received a $13,000 donation from the Carnegie Library Fund. It was opened on August 1, 1909. The front street is Dodd Street, and off to the left is Franklin Avenue (later Cleveland Terrace). Off to the right is the Second River and Watsessing Park. The library was enlarged in 1939 to more than double its original size.

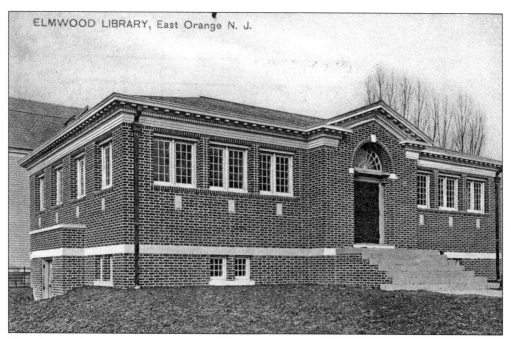

The Elmwood Branch, opened on January 11, 1912, was also built from a $13,000 Carnegie donation. Located on the corner of South Clinton Street (facing) and Elmwood Avenue, the library stood directly across from Elmwood Hose Company No. 5, diagonally to the Elmwood Public School.

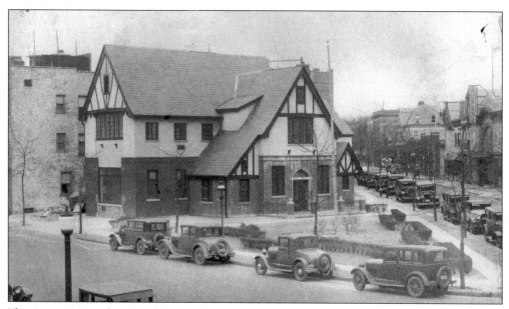

The Ampere Branch opened as a deposit station in 1915 at 67 Fourth Avenue. On March 17, 1923, it moved to a rented store at 57 Fourth Avenue and reopened as a full library. The branch transferred to this location on the corner of Ampere Plaza (left) and North Eighteenth Street (right) on March 17, 1931. Looking south on the right side of the photograph is the Ampere movie theater. (Courtesy of the East Orange Public Library.)

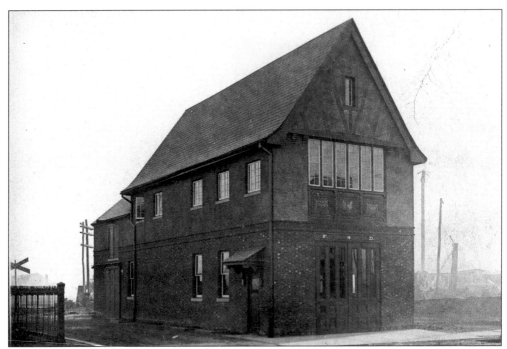

Organized on October 1, 1906, Hose Company No. 4 occupied the remodeled Driscoll Disposal Works on Springdale Avenue north of Centre Way (now Centerway). The hose company later moved to this location and remained here until 1930. The building was then remodeled for the Ampere Library. Note that this is the same building shown on the bottom of the previous page. (Courtesy of the East Orange Public Library.)

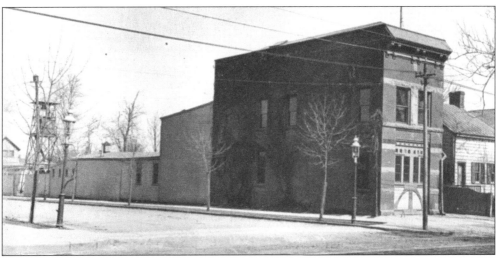

The first East Orange Fire Company was founded on January 25, 1879, but it was not until June 11, 1883 that the fire department was granted official standing. Eastern Hose Company No. 2, shown here, was organized on December 11, 1883, and located in a frame building on Grove Street north of Main Street. In August 1888, the company occupied this $3,807 building on the northeast corner of Main Street (front) and Hollywood Avenue (side). (Courtesy of the East Orange Public Library.)

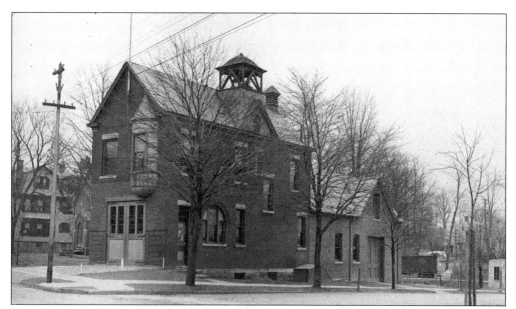

Organized on April 14, 1884, the Franklin Hose Company No. 3 was first housed in the original Franklin Schoolhouse. The company moved to this location, on the corner of Dodd Street (front) and Brighton Avenue (side), on January 1, 1890. It cost $3,757 to build. The railroad car in the background is resting on the Erie Railroad tracks. In October 1887, the Gamewell fire alarm system began to replace the use of bell towers. (Courtesy of the East Orange Public Library.)

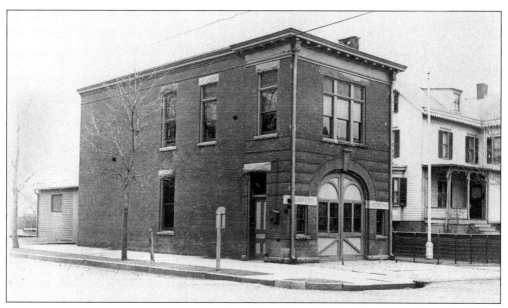

The Elmwood Hose Company No. 5 was organized on September 12, 1887, and a frame building was erected on the corner of Elmwood Avenue and South Clinton Street. In January 1895, the company occupied the building shown, which was constructed on the same site. The building, which cost $3,295, fronted on Elmwood Avenue. On November 11, 1901, the city council adopted the call system, and by March 1907, there were no volunteer companies. (Courtesy of the East Orange Public Library.)

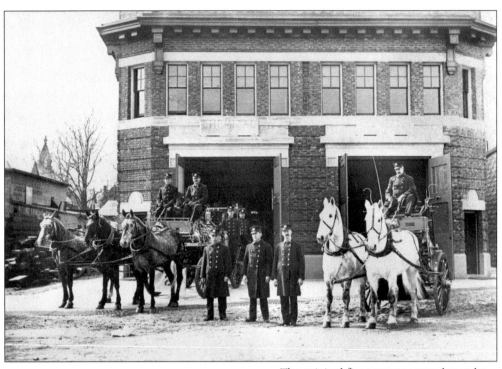

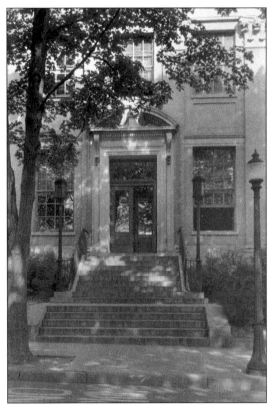

The original fire wagons were drawn by men, later replaced by horses, and finally by engines. Fire hydrants began to appear in 1882, and hoses replaced "bucket brigades." Chemical No. 2 replaced Eastern Hose No. 2 in 1909 and was relocated farther north on Hollywood avenue across from the Grove Street Railroad station. The building on the left is the Excelsior Stables Livery and Boarding. The tower in the background is the First Congregational church. (Courtesy of the East Orange Public Library.)

The East Orange Police Department was founded in April 1885. A frame structure station house was constructed between North Walnut and Winans Street. The first floor room was 10 by 12 feet and was shared by the town court. The frame structure was replaced by a brick building in 1892 that also served as city hall. The police department used the second floor. They remained there until 1929, when they moved into this building. (Courtesy of the East Orange Public Library.)

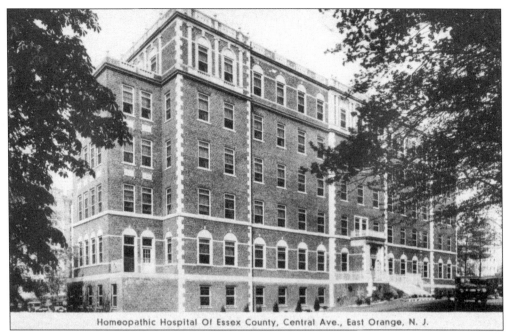

Homeopathic Hospital Of Essex County, Central Ave., East Orange, N. J.

Incorporated on March 21, 1903, the Homeopathic Hospital of Essex County leased a small building on Sussex Avenue and Third Street in Newark. In 1904, it moved to Littleton Avenue, where it remained until 1926, before moving to the northwest corner of Central and South Munn Avenues. The new building cost $700,000 and occupied what had once been the estate of William H. Baker. In 1938, the name was changed to the East Orange General Hospital.

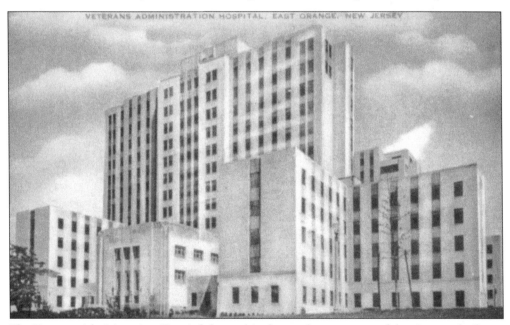

The Veterans Administration Hospital, located in the southwest corner of the city, was built at a cost of $26 million on land donated by the Bamberger family. It opened in September 1952. The original structure was built to house 1,138 beds.

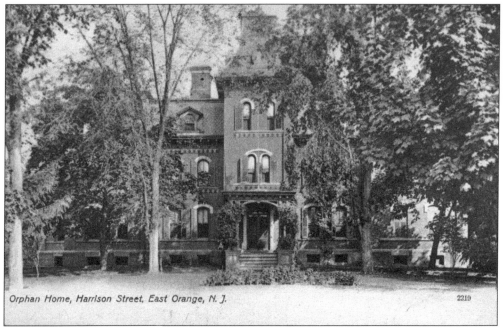

Orphan Home, Harrison Street, East Orange, N. J. 2210

The Orange Orphan Society was organized on December 11, 1854. This building was constructed on land donated by Caleb Baldwin and was dedicated on January 12, 1871. The three-story brick building cost $26,000 to erect. Built on an apex called "Crow Hill" at 197 Harrison Street, the Orange Orphan Home was bordered on the south by Orange Park and on the north by the estate of James Eggleston.

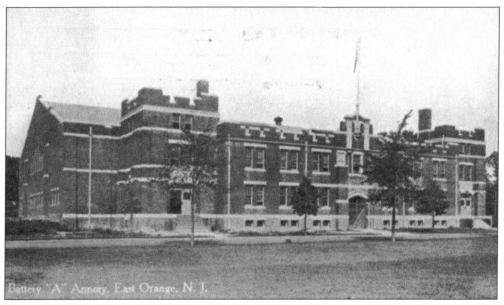

Battery "A" Armory, East Orange, N. J.

Battery A, Field Artillery, originally located on North Clinton Street near Carleton Street, moved to this location on June 23, 1912. Situated south of Park Avenue and fronting on North Oraton Parkway, the building extended back to North Munn Avenue and cost over $100,000. The battery saw action along the Mexican border in 1916 and as part of the 29th Division during World War I.

Four

SCHOOLS

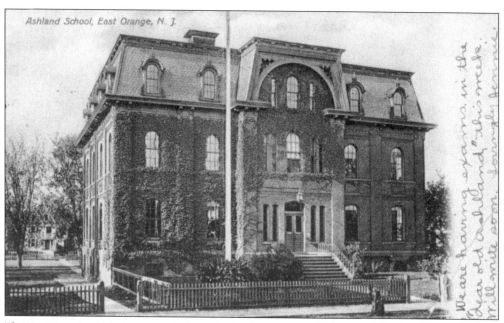

Ashland School, East Orange, N. J.

The East Orange school system predates the incorporation of the town. In 1835, East Orange was divided into three school sections: Eastern, Franklin, and Ashland. The first three schools were Eastern, Franklin, and the "White School House." The system continued to grow, adding more primary schools, two high schools, six parochial schools, and eventually three colleges. In 1945, *Look Magazine* ranked the East Orange school system among the nations' top 100.

The first Ashland School was the "White School House," located behind Brick Presbyterian Church on Prospect Street. After being sold to the church on July 30, 1870, a lot was purchased on Mulberry Street (now North Clinton Street) and the Ashland school, shown here, was opened on September 5, 1871. The cost for three stories, ten classrooms, and an assembly hall was $50,000. Four rooms were added in 1885.

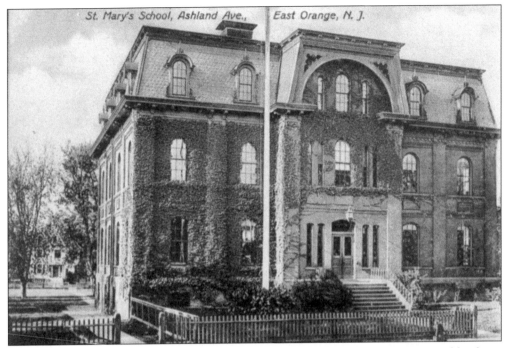

St. Mary's School, Ashland Ave., East Orange, N. J.

The author can find no record that this school was ever named St. Mary's; however, Ashland was indeed sold to Our Lady Help of Christians (OLHC) in 1906. OLHC had started a school in 1883, one year after the church was founded. Classes for the first 102 students were held in a wooden building on the church property. The building shown is still standing and still in use.

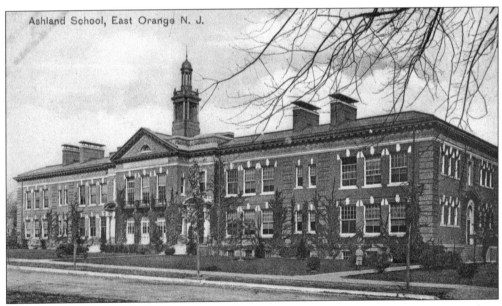

Ashland School, East Orange N. J.

The Ashland school pictured here on Park Avenue near North Clinton Street was opened on January 7, 1907, at a cost of $160,000. It held 18 classrooms, an auditorium, and several other rooms. Ashland was named by a trustee who admired statesman Henry Clay. Clay's home was called Ashland and thus the school was named. This school burned in December 1989.

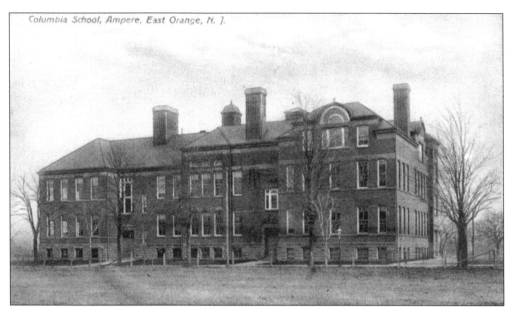

After a new district was created in 1892, a new school was built. The school was constructed on the corner of Grove Street and Springdale Avenue and named in honor of the 400th anniversary of Christopher Columbus's discovery of America. Occupied in 1893, Columbian School originally contained eight rooms and cost $30,000. This photograph was taken before an addition was made in 1913.

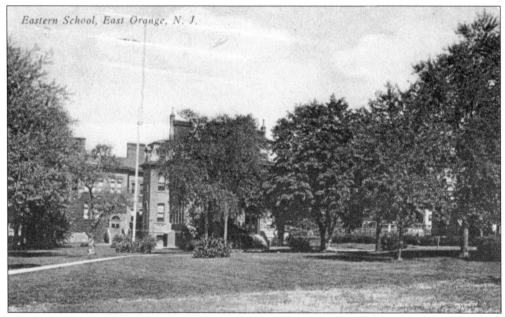

Eastern School, East Orange, N. J.

The first Eastern School was a two-story frame building. The school pictured here, c. 1905, was located on Main Street between North Street and North Maple Avenue. Dedicated on September 4, 1871, it held eight classrooms and a third-floor auditorium. The school's auditorium was soon divided into four rooms that served as the high school until 1890. An additional wing of eight rooms, seen on the left, was added in 1896. The auditorium was removed in 1936.

37

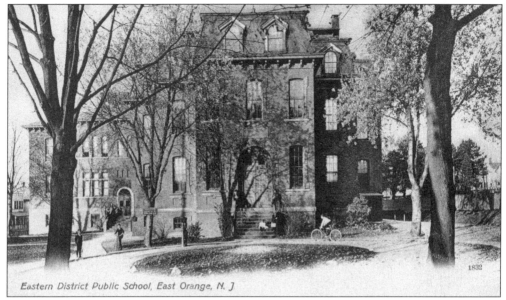

Eastern District Public School, East Orange, N. J

Eastern's graduates included author Zane Grey, Adm. Raymond Spruance, commander of the Central Pacific area; and Rear Adm. Frederick W. Pennoyer Jr., who accepted the Japanese surrender and sent the flag to Eastern School. Eastern was torn down in 1965. *Dear old Eastern is our favorite / Best of schools we know / We will join in joyful praises / To the Gold and Blue. // Lift the chorus, speed it onward / Loud her praises tell / We will e'er be true to her / Where ever we may dwell.* (Taken from *A Centennial History of East Orange.*)

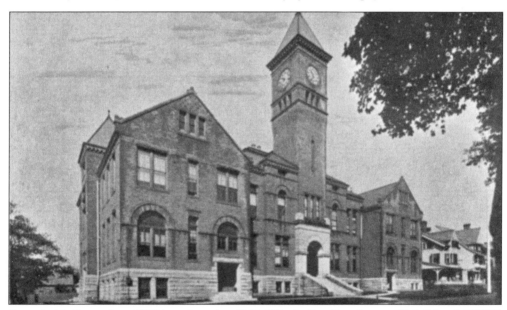

Occupied in December of 1891, and costing $120,000, the first East Orange High School (EOHS) was erected on Winans Street between Main and William Streets. It contained ten classrooms, two study rooms, a drawing room, a laboratory, and a gymnasium on the third floor. Two basement rooms were later used for manual training and mechanical drawing. The building was torn down to make room for an addition to the new high school c. 1958.

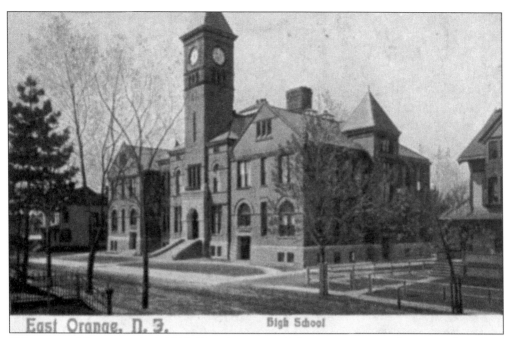

This postcard is postmarked 1906. The class song of that year captures the spirit of so many EOHS classes: "We're the finest State in the land, / In the State we're the finest town, / And our school is simply grand, / While our class has won renown. // Whene'r a man wins fame / In the years that soon will pass, / If you ask from whence he came, / They'll say our own glorious class." This can be sung to the tune of "The Big Red Team."

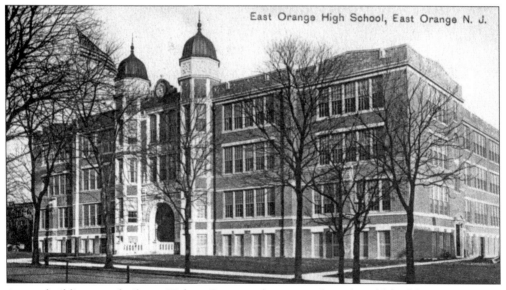

A new building was built on Walnut Street and connected to the old building, opening in September 1911. The new auditorium held 1,200 people. Other additions were made in 1923 and 1960. The school had a newspaper called the *News* that was started on October 13, 1899, the same year the football team won the state championship. A Code of Conduct was outlined by the student council in the *Red and Blue Handbook*.

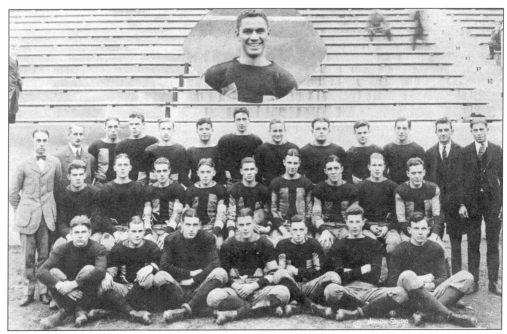

Football was an important part of the EOHS experience. The Thanksgiving Day rivalry with Barringer High School lasted almost 100 years. This photograph was taken in Ashland Stadium (renamed Marten's Stadium in 1952), where EOHS played. Captain John Failing (insert) led the 1921 team. Try this cheer: "Rap, rap, rap, / Ree, ree, ree, / We've got [Barringer] up a tree! / With a razz-ma-tazz / And a hi-de-ho, / Come on East Orange! / Go, team, go!"

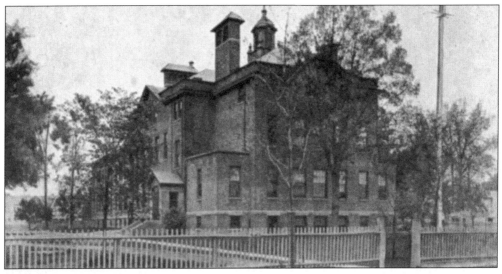

Known first as South Ashland, Elmwood School was erected on South Clinton Street near Elmwood Avenue in 1887. The original building contained four classrooms. In 1890, eight more classrooms were added. The six additional classrooms and third floor auditorium, built in 1902, made up the building shown here. In 1917, an additional building with 16 classrooms, a gym, a shop, and household unit room were added. That structure still stands, but the original school building was taken down in 1955.

Franklin Public School, Dodd Street, East Orange, N. J.

The first Franklin school, named for Benjamin Franklin, was located on Dodd Street and Girard Avenue. It cost $233.91 to build. It was used until this building was constructed on the south side of Dodd Street (east of Midland Avenue) at a cost of $14,447. Opened on April 24, 1874, it originally held four classrooms and an office. Four more rooms were added in 1884, and another eight rooms were constructed in 1898.

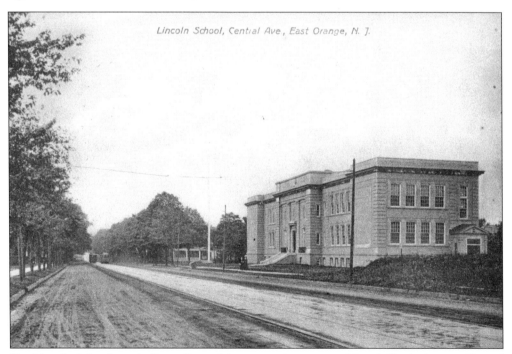

Lincoln School, Central Ave., East Orange, N. J.

The Lincoln School was built on Central Avenue at the corner of South Maple Avenue. Named after the President, it was opened in September 1908, but dedicated on February 12, 1909. Lincoln's words, "We cannot succeed unless we try," are carved in stone above the entrance. This view, from *c.* 1907, looks west on Central Avenue. Notice the two trolley cars on the left.

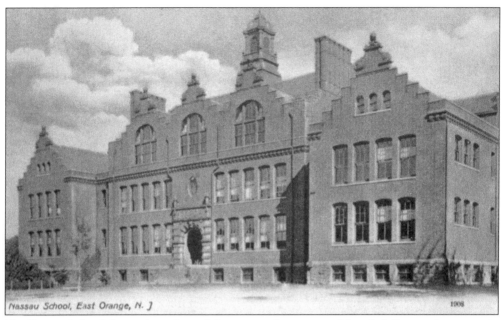

Nassau School, East Orange, N. J. 1908

The Nassau School, located on Central Avenue at the corner of South Arlington Avenue, was opened in February 1899. Originally, there were only the 12 rooms shown here. Additions were made in 1909 and 1927. In 1934, the Works Projects Administration (WPA) added a library. The school was named for William of Orange, the Count of Nassau who led the fight for Dutch freedom against Spain, out of respect for the Dutch architect who designed the school.

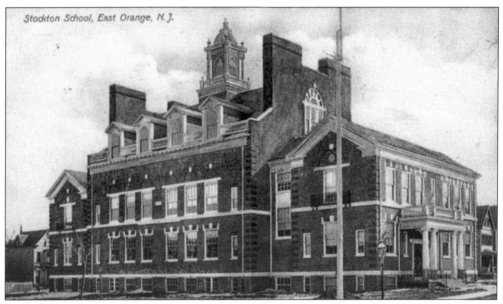

Stockton School, East Orange, N. J.

Stockton School was opened on February 13, 1905. Built on William Street between North Nineteenth Street and Greenwood Avenue, the school contained 12 classrooms and a third-floor auditorium. Still in use, the school was named for Richard Stockton of Princeton, a signer of the Declaration of Independence. His coat of arms was designed into a stained-glass window placed in the auditorium. Greenwood Avenue is on the right.

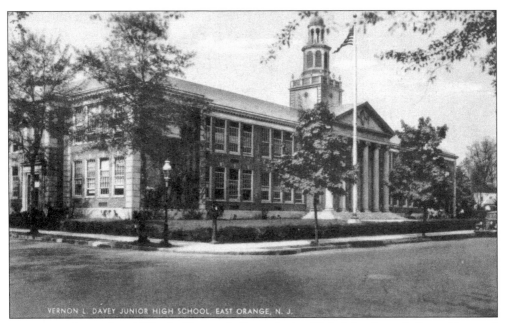

Opening in September 1930, the Vernon L. Davey Junior High School was built on Elmwood Avenue and encircled by Burnet Street, Rhode Island Avenue, and Eppirt Street. It was named for Vernon L. Davey, who had been a superintendent of the East Orange School System. Rhode Island Avenue was originally called Maple Avenue and later Dutchess Avenue.

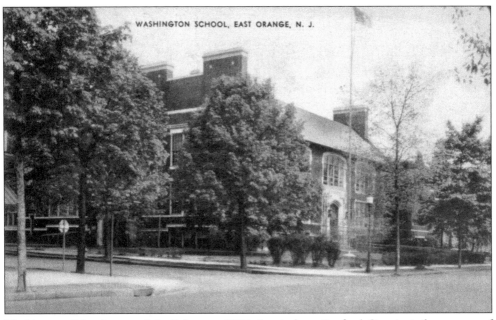

Washington School opened in February 1912. Located on Sanford Street at the corner of Kenwood Place, the building shown here had 12 classrooms. Eight more rooms were added in 1920. The school was named for George Washington by the Orange Chapter, New Jersey Society, Sons of the American Revolution. In 1916, it became the first school in East Orange to have a dental clinic.

There were once five Catholic Grammar Schools in East Orange: Our Lady Help of Christians, Holy Name, Blessed Sacrament, St. Joseph's, and Our Lady of All Souls (OLAS). OLAS, located on Fourth Avenue near North Grove Street, had its beginnings in 1909. Father John Callaghan of Our Lady Help of Christians saw the need for a Catholic church in the Ampere section. A house at 174 Rutledge Avenue was purchased on January 3, 1910, for use as a mission chapel. Toward the end of 1910, the rear of the building was extended, and the church was nicknamed the "Bowling Alley Chapel." The Reverend John J. Murphy was the first pastor of OLAS, appointed on June 17, 1914. The land on which this building stands was purchased in 1916. Construction was started for a combination school and church in 1927. The first Mass said in the church was the Christmas midnight Mass in 1927. In September 1928, the school was opened. Teaching was conducted by the Sisters of Charity. The front portion of this building contained eight classrooms, an office, and a supply room. The rear held a first-floor church. Below the church was a cafeteria. Kindergarten classes, as well as Sunday Masses, were held there.

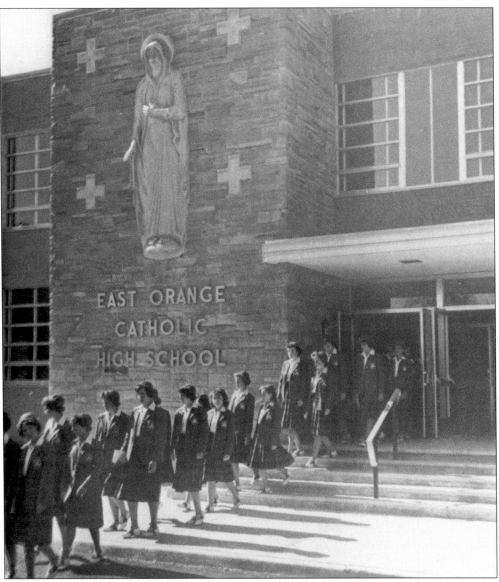

The Newark Normal School of Physical Education, founded in 1917, moved to East Orange in 1926. It was renamed Panzer College in 1932. In 1958, the school merged with Montclair State College and relocated there. The archdiocese of Newark purchased the Panzer College buildings and some additional properties at 139 Glenwood Avenue and opened East Orange Catholic High School on September 12, 1958. The all-girl school had 96 freshmen. In March 1959, work was started on a new school building, which was opened on September 12, 1960. The school remained in East Orange until 1980, when it merged with Archbishop Walsh High School in Irvington. Essex Catholic High School (of Newark) then moved to this location. The EOCH alma mater: "East Orange Catholic High School, Alma Mater true, / Gladly we salute thee / Raise hearts young and free; / We will long remember goals you led us to / We'll treasure friendly mem'ries of our days with you. / / Friends and games and school days, lessons, too, we love, / Waiting for the future / Wond'ring, questioning of / What later life will bring us, be it smile or sigh, / We will always love East Orange Catholic High."

Clifford J. Scott High School, named for the superintendent of schools in East Orange from 1921 to 1936, was built at a cost of $697,000. Located on the corner of Renshaw Avenue and North Clinton Street, the colonial-style building was dedicated on October 15, 1937. A $1.2 million addition was made in 1956. In true "Scottish" tradition, the school newspaper was named the *Bagpipe* and the yearbook was named the *Tartan*.

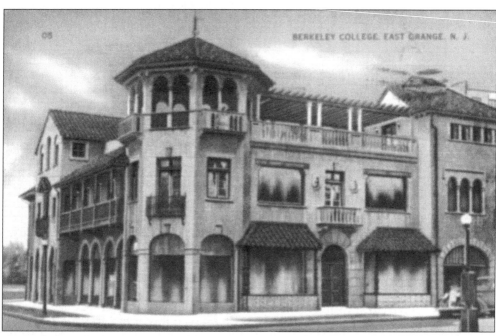

The Berkeley School (now Berkeley College) was founded in 1931 and named after Lord John Berkeley. The school originally occupied the third floor of the Dane Building, shown here, which was built in 1930. A store called the Blue Door housed the first two floors. Located on the southeast corner of 24 Prospect Street (left) and William (right) Street, Berkeley instructed young men and women in business and secretarial skills. The school was relocated on September 9, 1976, and the building was torn down in 1999.

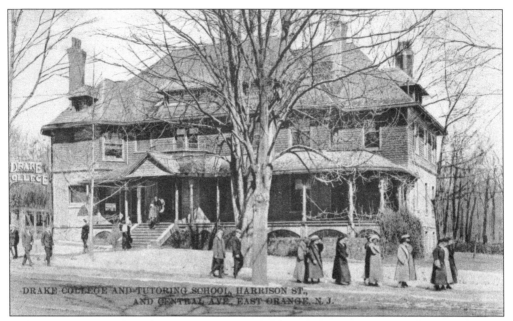

Drake College opened on the northwest corner of Harrison Street and Central Avenue *c.* 1910. A business school, Drake offered courses in finance, banking, bookkeeping, shorthand, typewriting, English, civil service, and mechanical drawing, as well as private secretarial courses. The school also secured positions for its students. The school fronted on Harrison Street.

Founded in 1893 in Brooklyn, Upsala College moved to Kennilworth, New Jersey, in 1898. In 1924, the college came to East Orange. Upsala was named in commemoration of the 300th anniversary of the Upsala Synod of the Church of Sweden. The college was under the control of the Augustana Synod of the Swedish Lutheran Church.

47

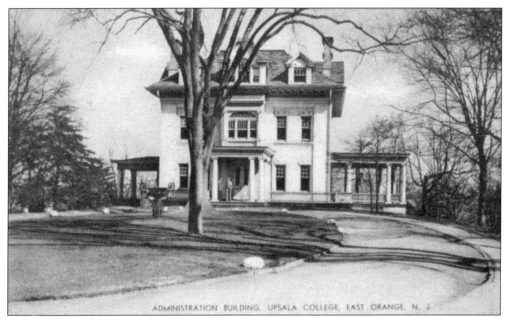

ADMINISTRATION BUILDING, UPSALA COLLEGE, EAST ORANGE, N. J.

Old Main was originally the William Thayer Brown mansion at 172 Prospect Street. Brown dealt in athletic goods and worked in New York. His wife was Mary Spaulding, of Spaulding sporting goods. Brown called his estate Long Meadow, but most called it King's Folly. King, the previous owner, had been involved in the construction of the first horse-drawn trolley line from Orange to Newark. Old Main provided the first classrooms for Upsala College.

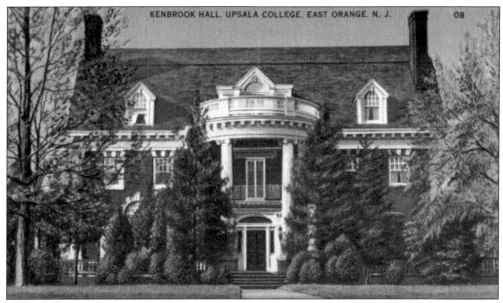

KENBROOK HALL, UPSALA COLLEGE, EAST ORANGE, N. J. 08

Kenbrook Hall, at 155 Prospect Street, was originally the Charles Hathaway mansion, located on the corner of Springdale Avenue. It first served as a women's dormitory. Later, an addition was made to serve as a cafeteria. Although many appeals were made, lack of finances eventually closed the college in May 1995. An Upsala yearbook slogan read, "We're Upsala born and Upsala bred, and when we die we'll be Upsala dead."

Five
CHURCHES

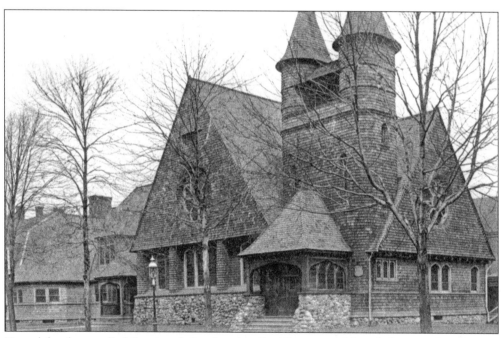

Newark has been called the city of churches, but East Orange could easily have made a claim to that title. At one time, the city had 47 churches representing 12 denominations—this in a city of less than 4 square miles. East Orange was founded in a theocratic society, and religion has always been a big part of its structure. Many of the churches seen in the following photographs are still standing and still hold services.

The Arlington Avenue Presbyterian Church was founded in the early 1890s. There had been few churches in the area, so local residents began to hold services in a barn at 20 Hamilton Street. In October 1892, they petitioned the Morris-Essex Presbytery to found a community church. The petition was granted, and a church was constructed on the corner of Springdale and North Arlington Avenues. It was dedicated on June 8, 1893.

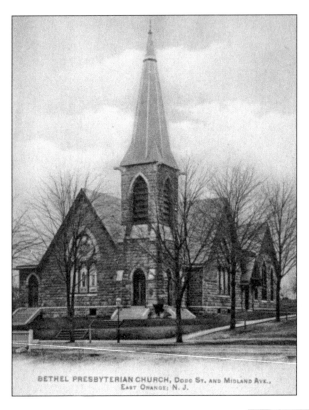

BETHEL PRESBYTERIAN CHURCH, Dodd St. and Midland Ave., East Orange, N. J.

The Bethel Presbyterian Church was completed in 1891 on land donated by Josiah F. Dodd, but its beginnings go back as far as 1817. At that time, meetings were held in one of the copper shops located near this site at the northwest corner of Dodd Street and Midland Avenue. Services were moved in 1866 to a chapel erected at Dodd Street and Brighton Avenue. This church was dedicated on Sunday, November 8, 1891.

The Second Presbyterian Church of Orange was completed in 1831 at the northwest corner of Main and Prospect Streets. Constructed of brick, it was the first church built in East Orange. Nicknamed "Brick Church," the name soon applied to the entire area. The church was remodeled in 1878 to the form shown here. In 1890, the name was formally changed to Brick Presbyterian Church.

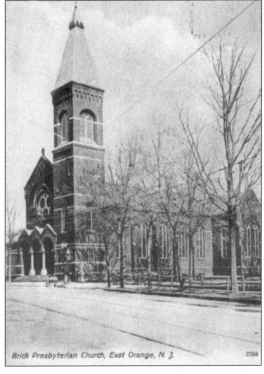

Brick Presbyterian Church, East Orange, N. J. 2234

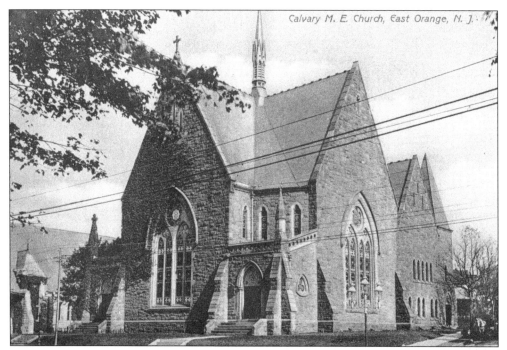

The first Calvary Methodist Episcopal church was erected on the corner of Mulberry (North Clinton) and William Streets and dedicated on June 12, 1870. Work was begun on this structure at the corner of Main and North Walnut Streets in 1885. It was dedicated on January 30, 1887, and the cost was $80,000. Additions were made in 1910. This church burned in the 1990s, but has been replaced with a new structure. Christ Church is on the left.

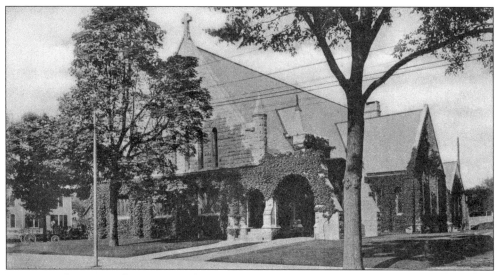

On September 15, 1868, a group of 20 people met in the East Orange Railroad Station and elected to start a parish called St. John's. Ten days later, they changed the name to Christ Church. The first church was built on the current site, the northeast corner of Main and North Clinton Streets, in December 1870. After several additions, it burned on December 23, 1888. The new church, shown here, held its first services on Easter Sunday, March 29, 1891.

51

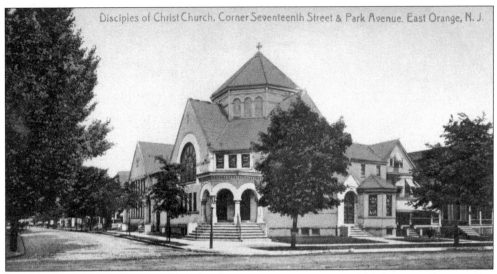

In 1899, three men riding the train from East Orange to Hoboken decided to start the Disciples of Christ Church. The first meetings were held in a rented store on the corner of Fourteenth Street and Park Avenue. A chapel was built on the corner of North Seventeenth Street and Park Avenue in May 1901. The chapel was later moved to build this structure, which was dedicated on November 29, 1908. This view looks northward on North Seventeenth Street.

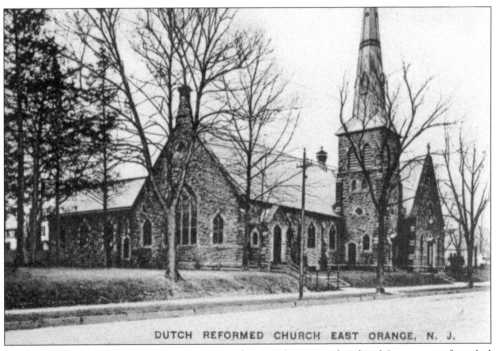

DUTCH REFORMED CHURCH EAST ORANGE, N. J.

The Dutch Reformed Church, on the corner of Main (shown) and Halsted Streets, was founded in 1875, the result of a difference of opinion between the pastor of Brick Presbyterian Church and other church officers and members. Dr. George S. Bishop and 130 members of Brick Presbyterian formed the new church and constructed this edifice in 1875. It was nicknamed "the Brownstone Church." The cost was just over $30,000.

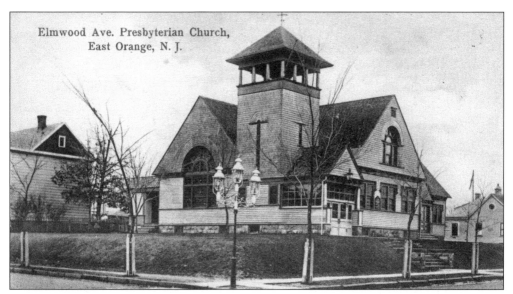

Started as a chapel of Munn Avenue Presbyterian, Elmwood Presbyterian Church was founded in 1872. The first chapel was built in 1874 on land donated by Anna M. Trippe on the southwest corner of Elmwood Avenue (right) and West Street (left—now Shepard Avenue). This church was completed on the same site in December 1889. The tower just visible above the house on the right is Elmwood Public School.

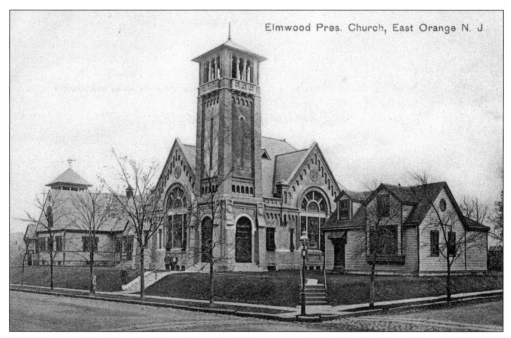

This Elmwood Presbyterian Church was built just west of the old church on Elmwood Avenue (left) and Eppirt Street (right). It was erected in 1910. On the left is the first church. The author suspects that the building on the right is the 1874 chapel. Frank M. Shepard served as superintendent of the Elmwood Sunday School for 32 years. Shepard Hall in Elmwood Church was named for him.

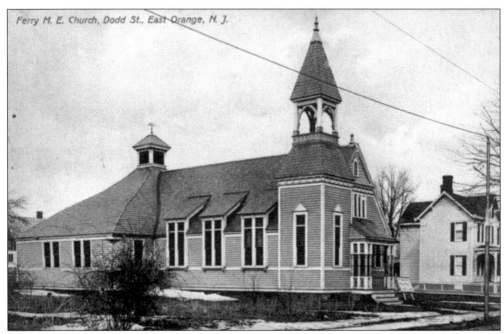

The Ferry Methodist Episcopal Church was dedicated in the autumn of 1880. Located on the northwest corner of Dodd Street and Cottage Place, the church was not named for the first pastor, Edward S. Ferry, but for his father, George J. Ferry. The senior Ferry was the mayor of Orange and had contributed liberally toward the building of the church.

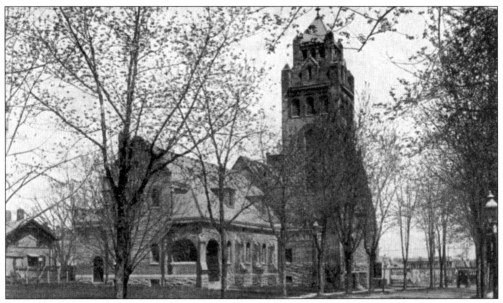

The First Baptist Church of Orange, organized on June 14, 1837, started to build its first church in 1842, but did not finish it until 1858. It was built on Mechanic Street (North Maple Avenue) and Railroad (later Church) Place. The congregation remained there until April 10, 1892, when this church, called the Hawthorne Avenue Baptist Church, was constructed on Main Street and Hawthorne Avenue. This view looks north on Hawthorne Avenue.

The initial First Baptist Church building, shown on the right, was purchased in 1891 by the Calvary (Colored) Baptist Church, which was founded in 1878. This first African-American church in the Oranges had been meeting in the basement of the old Calvary Methodist church on North Clinton Street. This view looks north on Maple Avenue. The bridge crosses over the DL&W Railroad tracks.

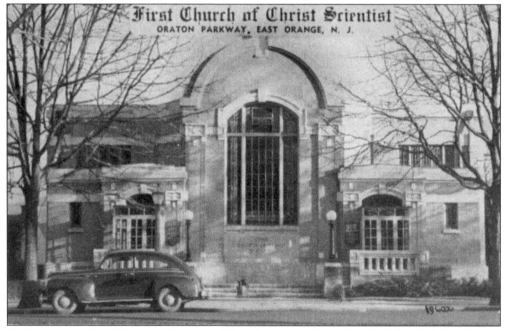

On September 28, 1910, a small group of East Orange residents founded the Christian Science Society. Incorporated on December 29, the members had no permanent residence until this building was completed in April 1926. The church was built at 154 North Oraton Parkway between William Street and Park Avenue. The church's reading room was located at 19 North Harrison Street.

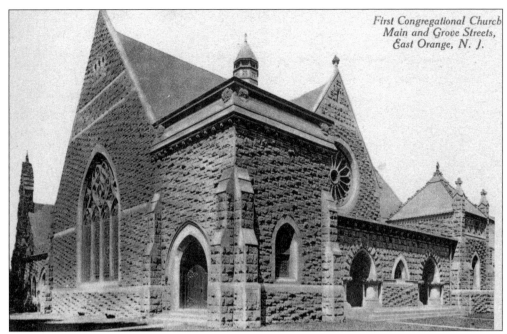

First Congregational Church
Main and Grove Streets,
East Orange, N. J.

On August 1, 1866, the Society of the Grove Street Congregational Church was organized. A church was erected in the fall of 1867 on the east side of Grove Street north of Main Street at a cost of $15,000. The dedication ceremony was held on December 18, 1867. An addition was made in 1871 and again around 1888. In 1890, an auditorium was added. The church was gutted in a three-alarm blaze on December 28, 1952.

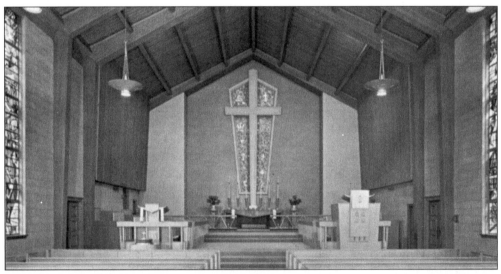

In June of 1893, a group of 38 people who were of Swedish descent met to form *Svenska Evangeliska Lutherska Taborforsamlinger*. The first church was constructed at 97 1/2 Summit Street in 1907, but the name was not changed to the First Lutheran Church of East Orange until 1929. The first church was sold in 1955. A new church, the interior of which is shown here, was constructed on Eastwood Street at the corner of Glenwood Avenue and dedicated on Palm Sunday, March 30, 1958.

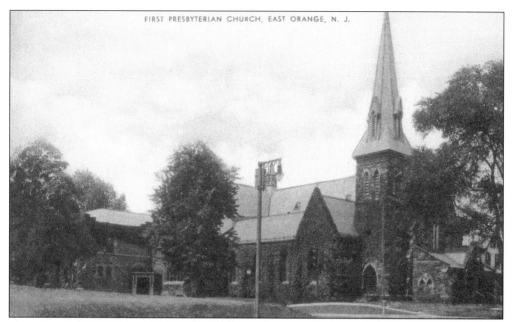

The First Presbyterian Church of East Orange, also known as the Munn Avenue Presbyterian Church, was organized on June 24, 1863. The edifice shown stands on the southwest corner of South Munn Avenue and Main Street and was dedicated on July 21, 1864. Additions were made to each side of the church in 1876. In 1888, the main auditorium was enlarged. The Andrew Reasoner Memorial Chapel (left) was dedicated on September 28, 1902.

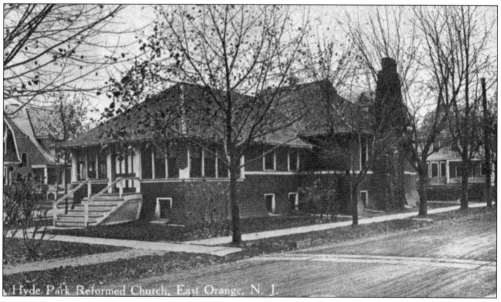

Hyde Park Reformed Church, East Orange, N. J.

Established in 1903, the Union Sunday School merged into the Hyde Park Reformed Church. On April 16, 1904, the congregation purchased the Hyde Park clubhouse for $5,000 and converted it into a church. Located at the juncture of Whittlesey Avenue and Wilcox Place, the church was purchased in May 1932 by the Church of Jesus Christ of Latter Day Saints. This building was torn down to make room for the Garden State Parkway.

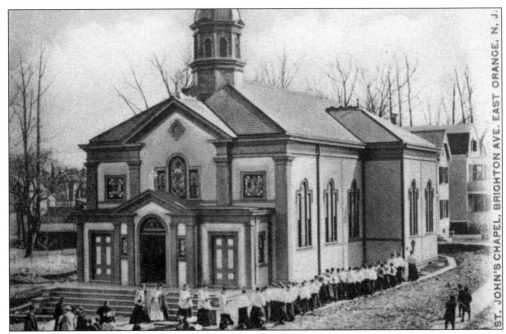

In 1907, St. John's Chapel was constructed on Brighton Avenue at the corner of Everett Place (now Everett Street). It was a mission of St. John's Church in Orange and seated about 400 people. The new Church of the Holy Name Parish was established in 1910. Father Farley was the first pastor. He immediately saw the need for a parochial school, which he had built on North Park Street.

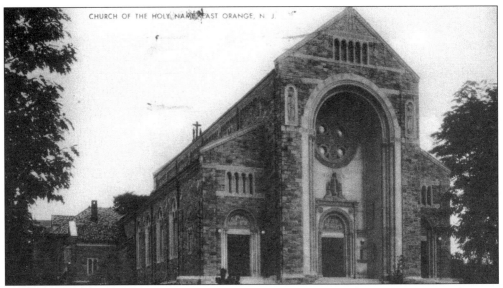

CHURCH OF THE HOLY NAME EAST ORANGE, N. J.

Father Farley died in 1925. His successor, Father Degen, negotiated the purchase of land on the northeast corner of Dodd Street and Midland Avenue for a church and school. The school was completed in 1928 at a cost of $217,000. The chapel was dismantled and the school auditorium used for Sunday Mass. This Lombardy Romanesque-style edifice was started in 1929 and completed in 1933 at a cost of $450,000.

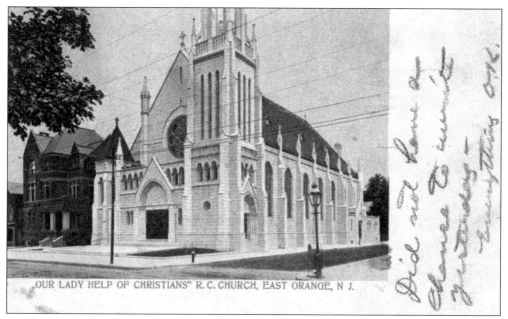

„OUR LADY HELP OF CHRISTIANS" R. C. CHURCH, EAST ORANGE, N J.

Our Lady Help of Christians Parish was founded in 1882. Father O'Connor, the first pastor, erected a small house of worship fronting on North Clinton Street at the corner of Main Street. Work was started on the church shown, which fronts on Main Street, about ten years later. This photograph shows the church before the spire was completed. The building on the left is the rectory. North Clinton Street is on the right.

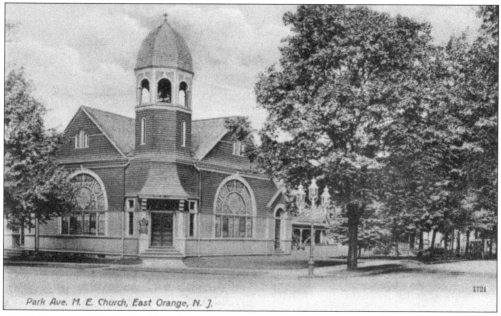

Park Ave. M. E. Church, East Orange, N. J.

The Park Avenue Methodist Church was formed in 1893. A temporary chapel was opened on the corner of Park Avenue and North Grove Street on September 10, 1893, at a cost of $1,700. The congregation soon outgrew the chapel and in 1898, the church shown was erected. This turn-of-the-century view looks north on Grove Street (right). Park Avenue is the front street.

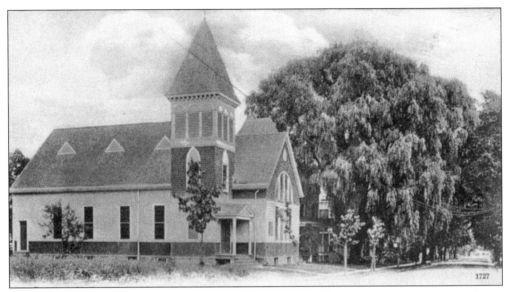

In 1894, a lot was purchased at the corner of Prospect and Norman Streets, and a church was erected at a cost of $13,000. It was dedicated on February 22, 1895. The Prospect Street Baptist Church was formally organized on July 10 of the same year. This *c.* 1905 view looks east on Norman Street (right).

In 1916, Father Sylvester Neri was appointed as spiritual leader of the Italian Catholic families living in the southwest corner of East Orange. He held the first Mass in a store on Crawford Street. In 1918, a carpenter shop on the northwest corner of Tremont Avenue and Telford Street was converted into a church. The church was therefore named for Saint Joseph the Carpenter. This building, built across the street, was dedicated on December 13, 1931.

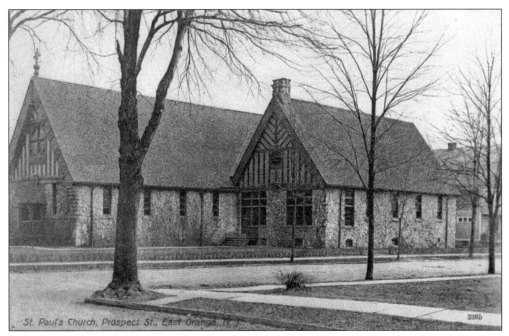

St. Paul's Church, Prospect St., East Orange, N. J. 2385

Begun in 1870 as a mission in a small chapel on Myrtle Avenue in Bloomfield, St. Paul's became independent on November 22, 1876. In 1893, a 14th-century gothic-style church was started on the corner of Prospect Street and Renshaw Avenue. The dedication occurred January 25, 1896, St. Paul's feast day. The church fronts on Prospect Street. Renshaw Avenue is on the right.

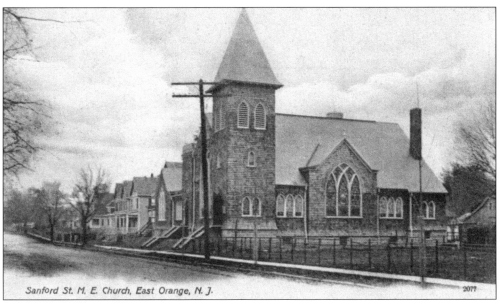

Sanford St. M. E. Church, East Orange, N. J. 2077

The Sanford Street Methodist Episcopal Church started as a Sunday school in 1873. Two years later, a small chapel was built on Sanford Street near Tremont Avenue. The chapel was moved to a lot on the west side of Sanford Street just south of Central Avenue in February 1896. In 1906, the construction of a new church was started that was dedicated on October 14, 1907. This *c.* 1905 view looks south on Sanford Street.

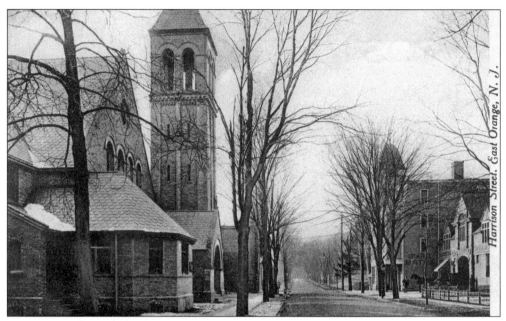

The first Trinity Congregational Church was a frame structure built in May 1872. This $26,000 church was built on the same site and dedicated on October 5, 1893. This view looks south on Harrison Street from Main Street. The first building on the right is the Berkeley Stables. Next to that building is the Allen Building, which housed the Orange Baths. Immediately past the Orange Baths, a railroad crossing sign marks the DL&W Railroad tracks.

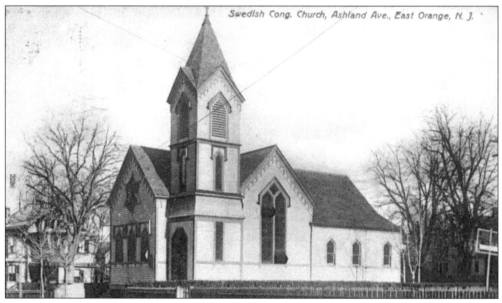

Trinity Congregational Church was the first home to the Swedish Sunday school class in 1886. Starting with 15 students, the class grew at a tremendous rate. A lot was purchased on the east side of Ashland Avenue between William and Main Streets for $2,000. The cornerstone for the church was laid on April 18, 1895, and the Swedish Congregational Church was dedicated on October 18. The cost was $6,000.

Six
LEISURE

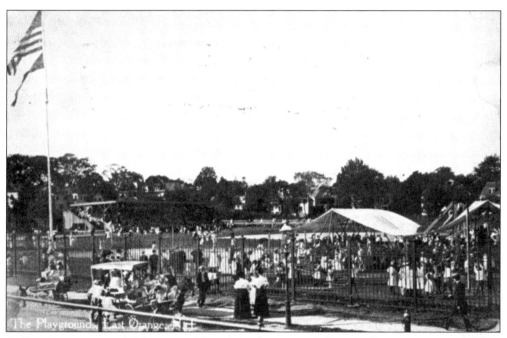

The Playgrounds, East Orange, N.J.

As East Orange grew and the necessities were taken care of, thoughts began to turn to leisure. With the turn of the century came the development of an impressive park system. Residents built meeting places for their clubs. Entrepreneurs established restaurants and hotels. Some of the parks, clubs, and hotels were small. Some were elaborate. But all of them had the meticulous attention to beauty and detail that defined East Orange.

The Orange Athletic Club, incorporated in 1886, secured a long-term lease on a field called the Oval, fronting on Eaton Place. On July 1, 1907, the newly formed playground commission purchased the field for $45,000. In October, the commission added some additional land and an entrance on Grove Place. Improvements were made and the park was dedicated on September 7, 1908. This view looks north from the Grove Street Station. The street shown is Eaton Place.

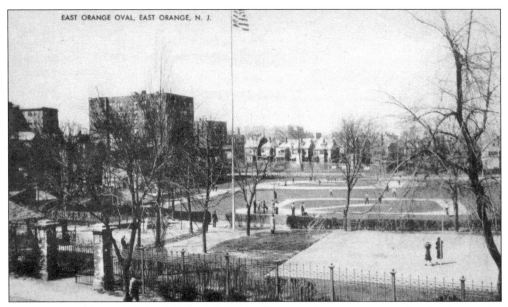

The Orange Athletic Club football team played colleges such as Princeton and Columbia on the Oval. East Orange High School won the state championship against Princeton Prep there in 1899. In 1910, the Old Orange Oval Gang Association was formed. Members included William Beebe, the world-famous ichthyologist, and Zane Grey, the author of westerns. The Oval encompassed 6.5 acres. The houses in the distance are on Grove Place while the apartment buildings are on North Grove Street.

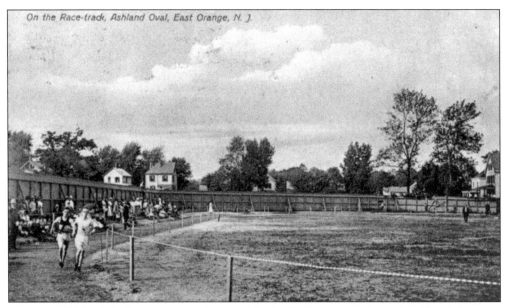

The 5-acre Ashland Oval was purchased in 1905 for $8,000 by the board of education. Interested citizens collected another $1,800 with which to build bleachers. East Orange High School moved its games from the Oval to this location. In 1920, the sale of bonds raised $100,000 for the building of a stadium on Ashland Oval. Built to accommodate 8,000 people, the stadium was completed in the 1920s.

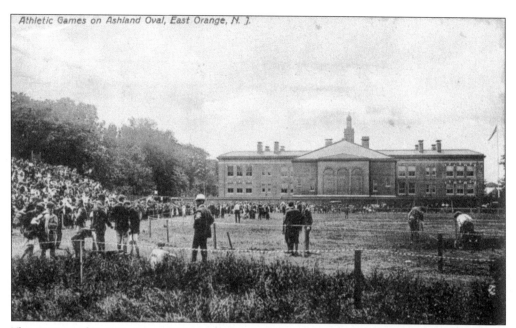

Athletic Games on Ashland Oval, East Orange, N. J.

The citizens of East Orange witnessed many exciting games against Barringer and Montclair in Ashland Stadium. The Thanksgiving Day games against Barringer were filmed and shown in local theaters. Ashland Stadium was renamed Marten's Stadium after retiring mayor Charles H. Martens on March 8, 1952. This view looks south toward the back of Ashland School, which fronted on Park Avenue.

Once covered by Springdale Lake, the area later known as Soverel Field was owned by Matthias Soverel, who harvested ice there from 1854 until he retired in 1888. Six acres of that land were purchased by the city in 1922 to be used as a dump. On February 27, 1927, the land was turned over to the recreation department and was opened to the public in 1929. Soverel Field became famous for the Panther jet donated to it by the Navy for use as play equipment. (Courtesy of the East Orange Public Library.)

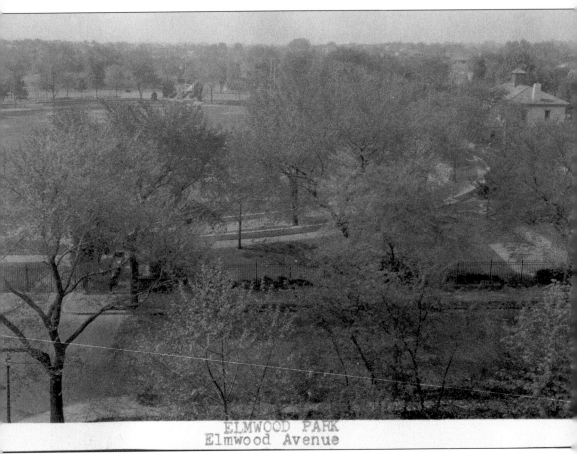

ELMWOOD PARK
Elmwood Avenue

In 1855, the Elmwood Home Association donated to the township the 9 acres of swampland that would become Elmwood Park. It was used as a place to dump ashes and refuse until 1910, at which time funds were appropriated to develop the land as a park. In 1917, Alden Freeman began spending what would eventually total approximately $150,000 to develop the park in memory of his father, Joel Francis Freeman. Alden Freeman was an East Orange resident, descended from John Alden, on his mother's side, and the treasurer of Goodyear Rubber. Freeman's offer included a group of statuary as part of the memorial. Designed by Ulric H. Ellerhuson, the statues, entitled *The Shrine of Human Rights*, were 8 feet tall on a 7-foot base. Also included were a bust of Pocahontas, Christopher Columbus, Confucius, and Frederick Douglass. Dedication ceremonies were held in the fall of 1921. A baseball diamond, seven tennis courts, and a field house were also erected. The field house became home to the Little Theater Group in 1935. It is visible on the right. The statues are barely visible at the top left center, beneath the flagpole. The road in the foreground is Elmwood Avenue. (Courtesy of the East Orange Public Library.)

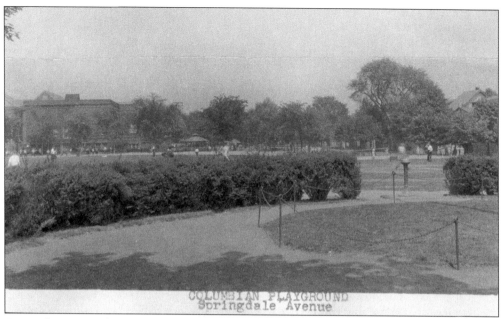

COLUMBIAN PLAYGROUND
Springdale Avenue

On April 18, 1919, 4.5 acres of land adjoining Columbian School were purchased by the city for use as a playground. Tennis courts and play equipment were provided, and the new playground was dedicated on September 5, 1922. The playground was run in cooperation with the school so that no field house was necessary. In later years, Columbian drew attention for the dock, boat, and fire engine used by the children. (Courtesy of the East Orange Public Library.)

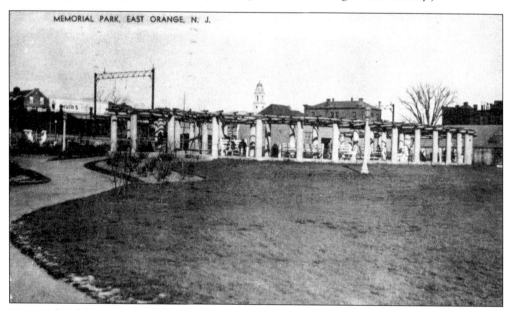

MEMORIAL PARK, EAST ORANGE, N. J.

Memorial Field was purchased on June 1, 1926, but was not opened until 1930. It was designed principally as a World War I memorial. The $25,000 memorial shown here, along with most of the rest of the park, was destroyed when Route 280 was built. A statue, sculpted by Charles Keck and dedicated on November 11, 1932, remains. On the base are the words "To Honor Those Who Kept the Faith 1917–1918." The dome in the distance is the city hall.

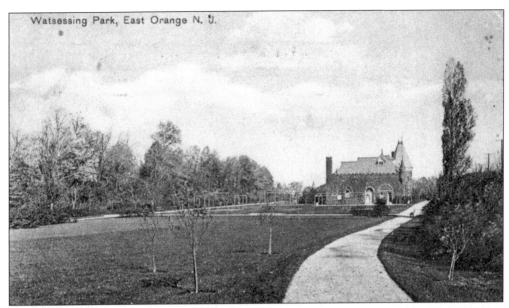

Watsessing Park, East Orange N. J.

The area in East Orange that became Watsessing Park was originally a sewage disposal plant, erected in 1886. Local outcry led to its demise on June 4, 1895. The land and buildings were turned over to the Essex County Park Commission on February 26, 1900. Part of the disposal plant was moved a short distance and became the field house seen in the photograph. This view looks south toward Dodd Street.

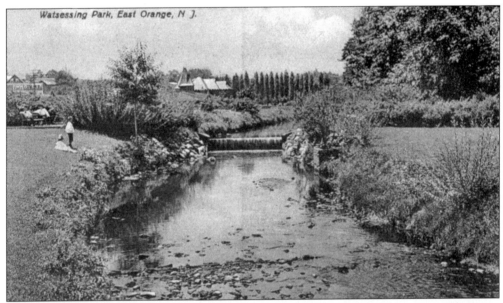

Watsessing Park, East Orange, N J.

This tranquil view of the Second River flowing through Watsessing Park was very different on September 13, 1777, when the only Revolutionary War "battle" fought in East Orange took place not far from this spot. General Clinton was leading a group of British soldiers on a foraging mission but was stopped on the Wardsessin (Watsessing) Plain by American militia. Clinton had 8 men killed and 5 taken prisoner, with 19 wounded and 10 missing. The Americans reported no deaths.

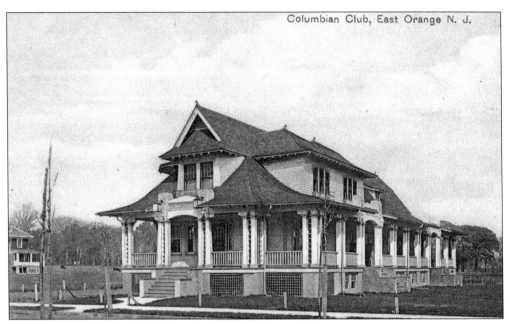

Residents met at Columbian School on November 18, 1908, to discuss organizing a civic and social club. On January 14, 1909, they adopted the name Columbian Club. A clubhouse was started June 22, 1909, on the corner of Grant and Roosevelt Avenues and was completed on January 15, 1910. This view looks north on Grant toward Arlington Avenue. In the field on the left, cows are grazing. In 1944, this building became the Central Christian Church.

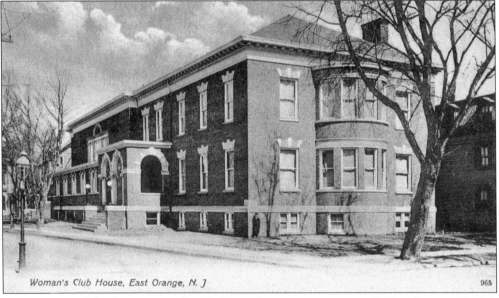

Woman's Club House, East Orange, N. J 965

The Women's Club of Orange was founded on February 7, 1872. It was the fourth women's club in America. The club became active in public affairs and grew so rapidly that a clubhouse was required. Located at 468 William Street at the corner of Prospect Street, the clubhouse was opened on April 18, 1906—the day of the San Francisco Earthquake. This view looks west on William Street. The building burned on January 7, 1931.

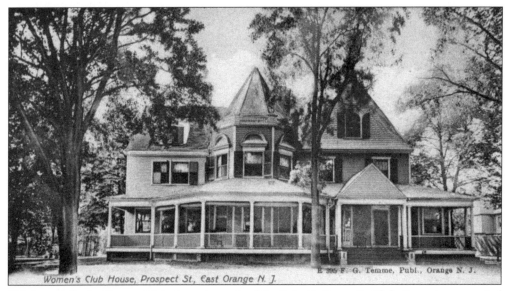

Women's Club House, Prospect St, East Orange N. J. E 596 F. G. Temme, Publ., Orange N. J.

This is actually the Orange Club. An outgrowth of the Eclectic Dramatic Club, it was incorporated on March 25, 1885. The club first occupied rooms in Appleton's Building, opposite Brick Church Station. They then leased this property at 20 Prospect Street and purchased it in 1887. The house was enlarged for club activities, and the grounds were arranged for outdoor games.

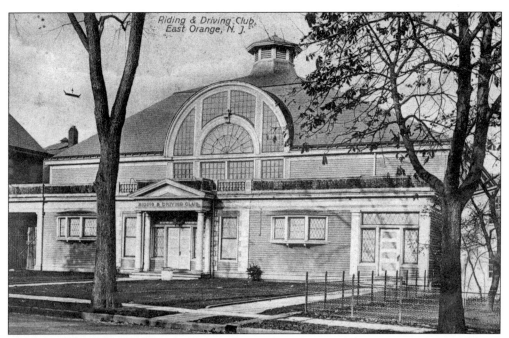

Riding & Driving Club, East Orange, N. J.

The Orange Riding and Driving Club had its inception in a riding class for ladies and gentlemen. Incorporated on June 8, 1892, the first president was Charles Hathaway. Initially, the club rented the riding academy on North Clinton Street for its meetings. In February 1895, this building was constructed at 9 Halsted Street. The L-shaped property also had a rear outlet on Prospect Place. The club held annual autumn horse shows and closed c. 1918.

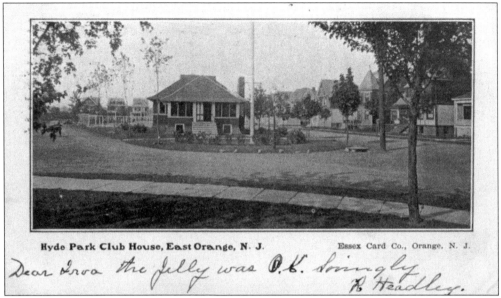

Hyde Park Club House, East Orange, N. J. Essex Card Co., Orange, N. J.

Dear Irva the jelly was O.K. Lovingly R Headley.

We tend to think of clubhouses and developments as recent occurrences, but Watson Whittlesey created the Hyde Park development c. 1900. Originally, this area was the farm of James Peck. Located behind the clubhouse and visible just to the left were tennis courts. The street to the left is Wilcox Place and to the right is Whittlesey Avenue. The homes behind the tennis courts are on Wilcox Avenue.

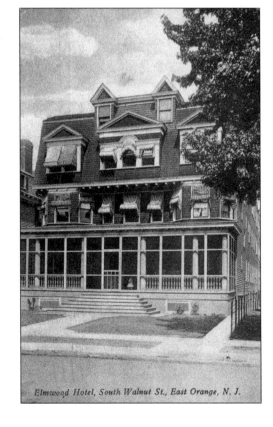

The Elmwood Apartment Hotel was located at 43 South Walnut Street. This seemingly small building extended very deep into the property, as can be seen on the far right of this photograph. This view looks west. The building is no longer standing.

Elmwood Hotel, South Walnut St., East Orange, N. J.

71

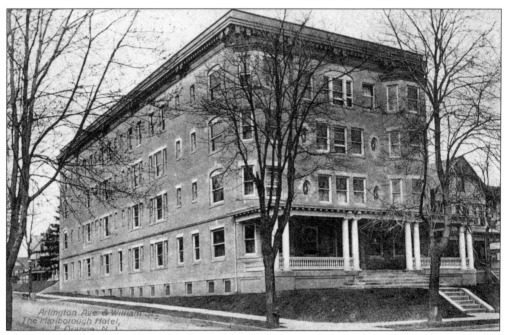

The Marlborough Hotel, located at 45 North Arlington Avenue on the northwest corner of William Street, was owned by the Rockefeller Hotel Company, which also owned the Elmwood Hotel. A 1910 advertisement indicated "Private bath, electric lights and telephone in every suite. Less expensive than housekeeping. Oranges almost like the Bermudas."

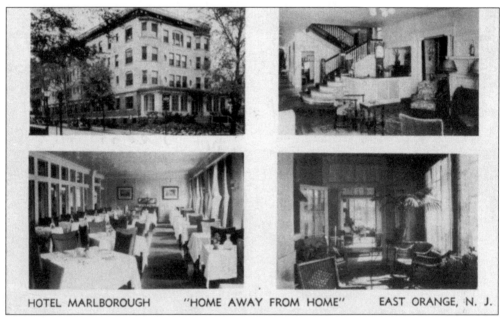

HOTEL MARLBOROUGH "HOME AWAY FROM HOME" EAST ORANGE, N. J.

"You'll like living at the Hotel Marlborough," claims the back of this postcard. "Private baths throughout. Residential hotel of distinctive charm. You'll like the real home atmosphere, the refined clientele, the cozy game room, the excellent food, and the modest American Plan rates. Room with bath $2.00. Double $3.00. Mr. and Mrs. Harold Lewis, Ownership-Management."

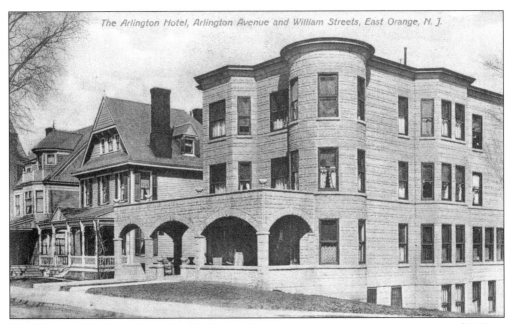

The Arlington Hotel was located at 50 North Arlington Avenue on the northeast corner of William Street. While seemingly in a prime location, city directories from the late 1910s show that it was vacant, possibly put out of business by the Marlborough Hotel across the street. Today, this lot is occupied by the YMCA Turrell Community Center.

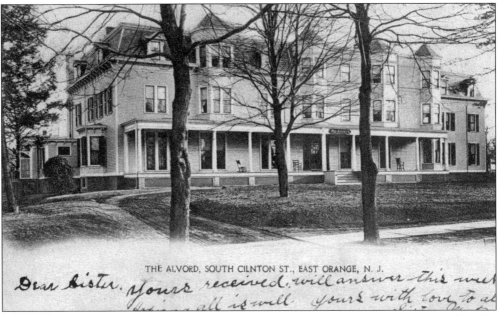

THE ALVORD, SOUTH CILNTON ST., EAST ORANGE, N. J.

The Alvord Hotel was located at 18 South Clinton Street, just south of the DL&W Railroad tracks. An advertisement from 1910 read, "Two blocks from Brick Church Station. An attractive suburban home with first-class service. Every possible comfort and the best the market affords. Single rooms; also rooms en suite, with bath; 45 minutes from New York City by Lackawanna Railroad. J. V. Alvord, Prop."

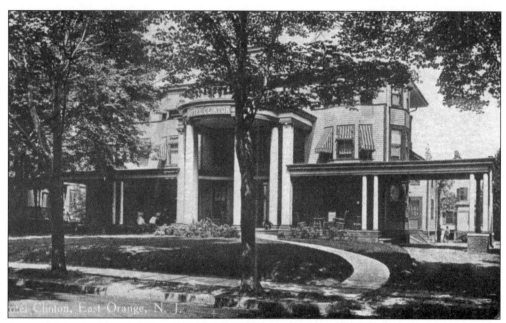

Across the street from the Alvord at 21 South Clinton Street was the Hotel Clinton. Their 1912 advertisement read, "Has the atmosphere of a costly home, with all the conveniences and service of a model hotel. Best of foods are carefully prepared and daintily served. Cleanliness is in every detail. Three minutes to trolley and Brick Church Station. Thirty-five minutes to Broadway. Edward M. Sammis, Prop."

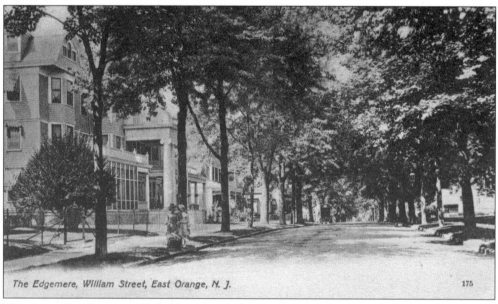

The Edgemere, William Street, East Orange, N. J. 175

The Edgemere Hotel, at 301 William Street, began as the Culbert residence. Over the years, several additions were made. By 1917, they advertised 100 rooms. Transient rates started at $3 per day. Breakfast and lunch were 75¢. Dinner was $1. Included in the house rules was the following: "sacred or classical music only played or sung on Sundays. Wm. H. Culbert, Prop." This view looks west from Winans Street toward North Walnut Street.

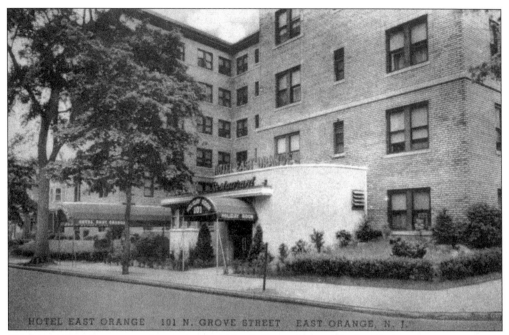

The Hotel East Orange was located at 101 North Grove Street. The hotel advertised, "150 rooms with bath and shower. Moderate transient rates. Attractive reductions to weekly and monthly guests. Ten minutes to centre of Newark. Half an hour to New York. And less than twenty minutes drive to any one of twenty golf clubs." The Holiday Room Restaurant was a later addition. Today, this is the East Orange Nursing Home.

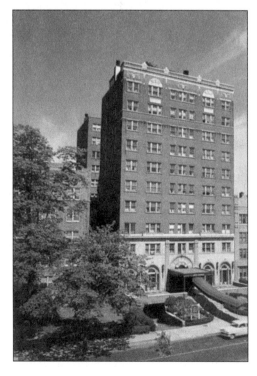

The Hotel Suburban, located at 141 South Harrison Street, was not only the best-known hotel in East Orange, but also one of the best known in the area. "A smart hotel in the Suburban Spirit operated in the Metropolitan Manner. Rooms and suites tastefully appointed. Air conditioned rooms available. Excellent facilities for every type of business, social or public event."

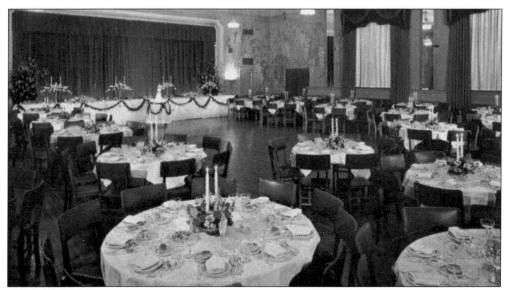

The Crystal Room was one of just several restaurants in the Hotel Suburban. The hotel also housed the Rose Room, the Mimosa Room, and Dick Killmar's Paris in the Sky atop the hotel. Killmar's offered "exquisite food in either the romantic Sidewalk Cafe with a view of New York's skyline, or in the luxurious Left Bank Room, where you can dance." The Crystal Room, originally the ballroom, could seat up to 500 people.

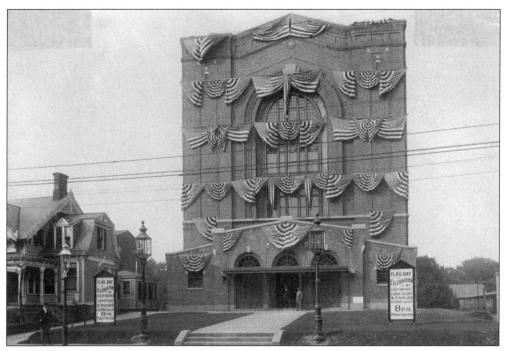

When the Lyceum opened in 1910, it was home to three different lodges of the Free and Accepted Masons. Many East Orange residents will recognize this as the Ormont Theater. An extension was added to front the theater on Main Street when it became the Ormont, but the portion of the building shown here changed very little.

Seven
DOWNTOWN

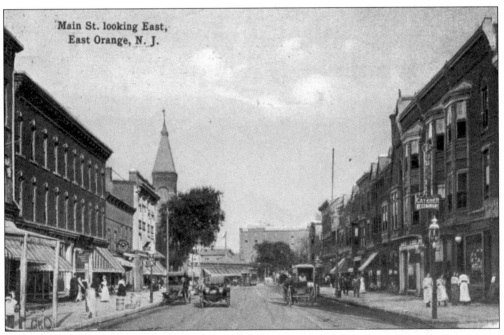

Main St. looking East,
East Orange, N. J.

While the success of East Orange can be attributed to its location and transportation system, its fame can be attributed to its downtown areas. The department stores and shops lining Main Street and Central Avenue were known throughout the region. By 1963, East Orange had 950 retail establishments. East Orange, a city of five distinct sections, also had two smaller downtown areas, one located in Doddtown and the other in Ampere. This view, taken from Harrison Street, shows Main Street c. 1910. The spire on the left is Brick Church. To the right of the church is Muir's (the building with the awning). The large building in the center is the Lyceum. On the right, at 561 Main Street, is the Purssell Company, caterers, bakers, and confectioners. Main Street was nicknamed the "Avenue of Churches."

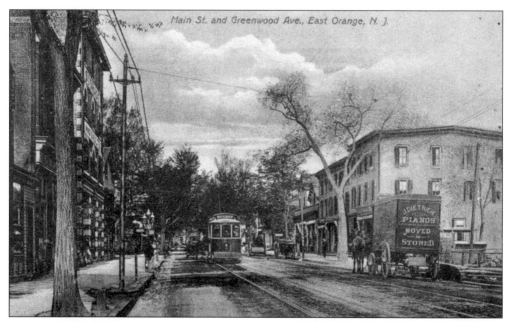

This view looks west on Main Street. Greenwood Avenue ends just in front of the Dietrich cart. On the left at 85 Main Street is J. Dietrich Storage. A 1908 advertisement read, "Vans for moving. Furniture crated and stored. Baggage express. China and Bric-a-brac carefully packed for transportation. Piano moving a specialty." The store next to Dietrich's (with the Coke sign) was a grocery owned by John Reeve.

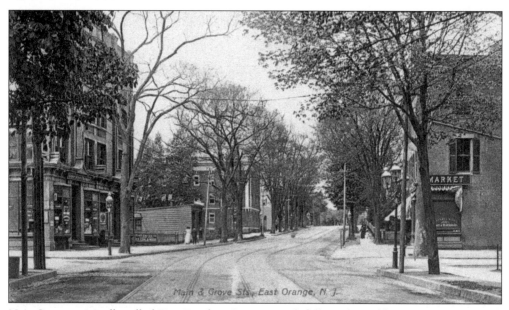

Main Street, originally called First Road or Orange Road, followed an old Native American trail. The twists and turns were made to avoid swamps. This view looks west. On the right at 136 Main Street is a meat market owned by Christian and Claus Menzel. On the left at 135 is the Grove Street Pharmacy. This was the location of Grovestend, the fourth post office opened in East Orange. This building, called National Hall, also served as the first library.

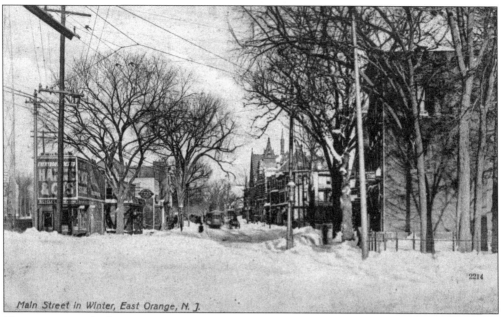

Main Street in Winter, East Orange, N. J.

This snow scene looks west on Main Street from east of North Arlington Avenue. Just to the right of the trolley, the old city hall can be seen. The spire belongs to the Calvary Methodist Episcopal church. On the left is a bicycle shop and coal company. Main Street was macadamized in 1869, about the same time that plank sidewalks were laid down. Gas lighting was added *c.* 1872 but were changed to electric lighting on December 3, 1921. Main Street was widened in the early 1920s.

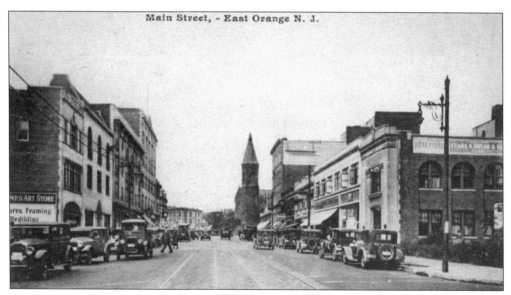

Main Street, - East Orange N. J.

This view looks west in the late 1920s. Lincoln Street is the cross street. The tallest building on the left is the Hale Office Building. The spire is that of Brick Church. On the top of the building on the right is an advertisement for Frank H. Taylor. Taylor was the largest real estate developer in East Orange and brought many of the insurance companies to the city after World War II. The first building with an awning on the right is F.W. Woolworth Co.

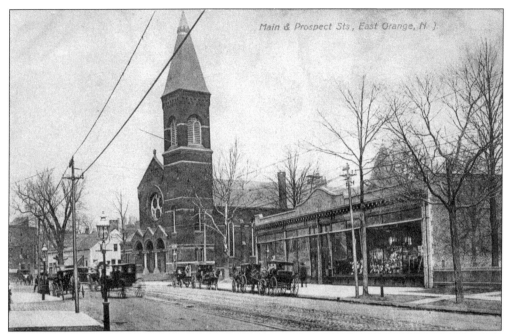

This turn-of-the-century scene looks west. The building on the right is Muir's. Ralph H. Muir was an Englishman who came to America in the 1880s. He was 30 years old when he opened his first dry goods store in 1881 near Brick Church. In 1906, he opened a hardware store for his brother, Arthur. Soon afterward, they opened a store together at Main and Prospect Streets.

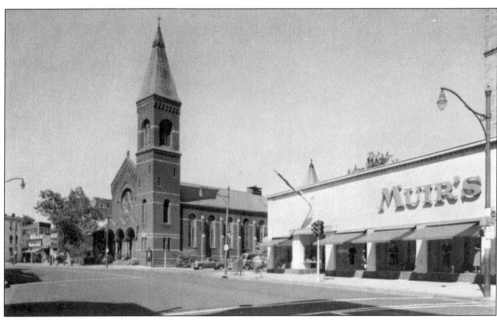

This is the same scene 50 years later. The trolley tracks are gone and the street is wider, but Brick Church and Muir's are still there. In 1921, Muir's added a 5,000-square foot expansion. They added a four-story addition in 1926. By 1941, Muir's had become the largest department store in Essex County. It closed in July 1974.

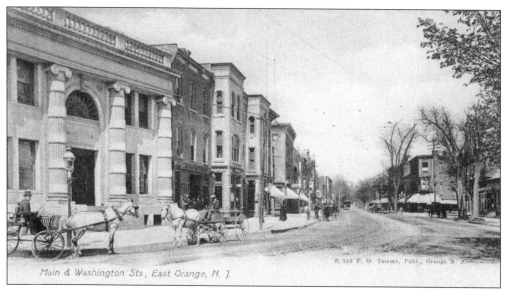

Main & Washington Sts, East Orange, N. J.

The coach on the left is just pulling out of Prospect Place. The third coach on the left is at Washington Place. The first coach on the right is at the entrance to Washington Street. This view looks west. On the left is the People's Bank, followed by a building owned by H.J. Condit, an apartment building called the Prospect, and then W.W. Jacobus, a grocer. Across Washington Place was Charles M. Decker & Brothers.

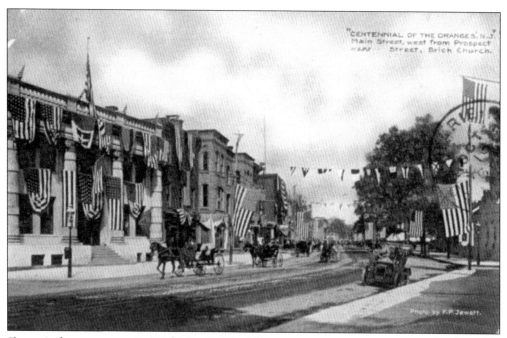

Shown is the same scene in 1906. The slightly different angle shows Prospect Street and the front of Brick Church on the right. Charles M. Decker & Brothers, the seventh store front on the left, was a large importer and grocer, with stores in East Orange, Orange, South Orange, Montclair, and Bloomfield. W.W. Jacobus & Company, the sixth storefront on the left, offered fruits, vegetables, poultry, fish, oysters, and game. "Philadelphia Poultry" was their specialty.

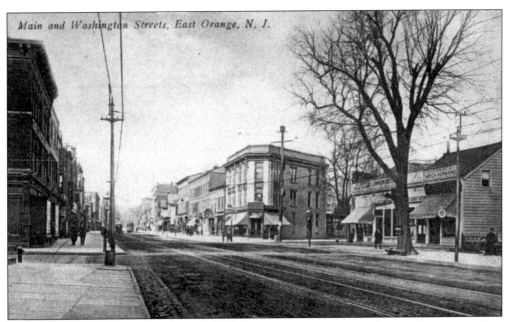

Here is the same scene one-half block farther west. Charles M. Decker & Brothers is the first building on the left. The large building in the center housed Albert Heineman Pharmacy. Across Washington Street on the corner was Edward B. Gillbard's Drug. The businesses from left to right were Henry S. Johnson, butcher, William A. Nearman, barber, and Emile W. Riegler, expert watch repairing.

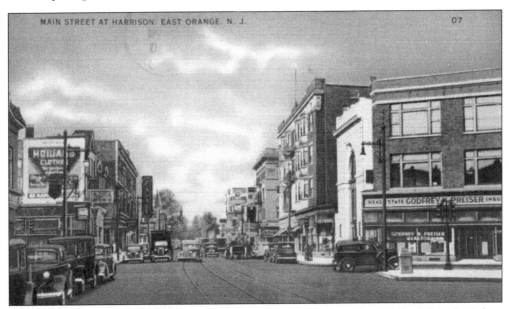

This is the end of the line. This view looks west from Harrison Street. On the left is the Palace Theater, marking the Orange border. The Palace Theater occupied a unique position—a portion of the theater was in East Orange, the rest in Orange. Unfortunately, East Orange still observed blue laws until 1932, thereby outlawing Sunday movies. The theater was roped off by East Orange policemen, and no one was allowed to sit in the East Orange seats.

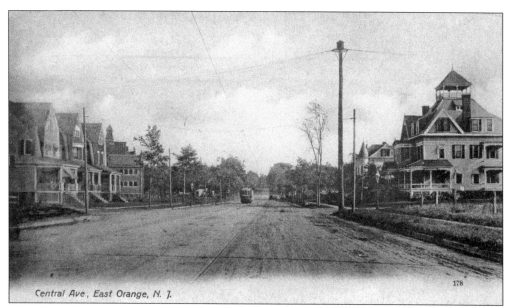

Central Ave., East Orange, N. J.

Central Avenue was opened on July 4, 1868. One year later, someone had fenced in a section of the street east of Grove Street to grow corn. This 1905 view looks east. The avenue on the left is Shepard. On the right is West Street, later renamed Shepard Avenue. The tower in the distance on the left is Nassau School. The first house on the right is probably the Camfield residence. Next to that is the McCabes Hotel.

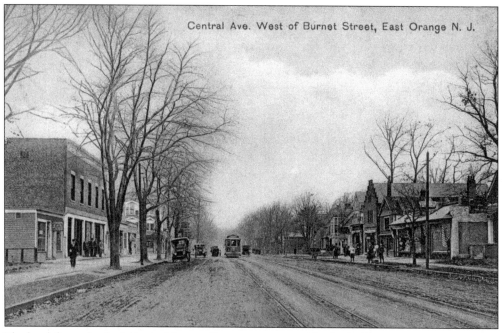

Central Ave. West of Burnet Street, East Orange N. J.

The land through which Central Avenue first ran was owned by the Baldwins, Freemans, Condits, Pecks, Harrisons, and a few others. By 1881, there were still only 14 houses and a military school between Newark and Orange. Horse races were held on Central Avenue until an ordinance was passed in 1882. The cross street, about where the trolley is located, is South Clinton Street.

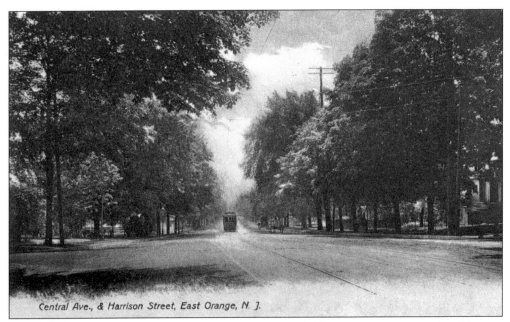

Central Ave., & Harrison Street, East Orange, N. J.

Development came quickly after the trolley came in 1904. The mansions were replaced by two family houses, then duplex houses, then apartments. In between came the shops, restaurants, banks, and department stores. B. Altman & Company, Peck and Peck, Black Starr and Frost-Gorman, Bachrach, S.H. Kress, Franklin Simon's, and Wiss Jewelers all found a home on Central Avenue. The view looks east. On the left is the estate of Inslee A. Hopper.

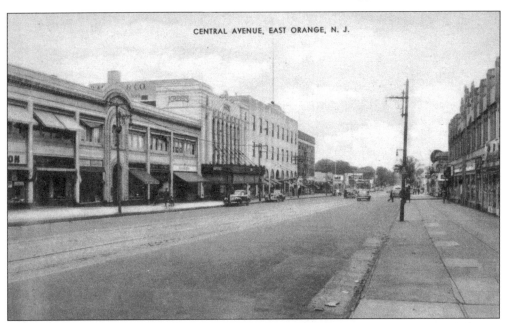

CENTRAL AVENUE, EAST ORANGE, N. J.

The same view, about 40 years later, shows B. Altman & Company and Kress on the left. East Orange had so many fine stores on Central Avenue that it was nicknamed "the Fifth Avenue of the suburbs." B. Altman & Company, which located on this site in 1931, outgrew its 60,000-square-foot store and moved to Short Hills. That store was replaced by Kresge on October 17, 1956.

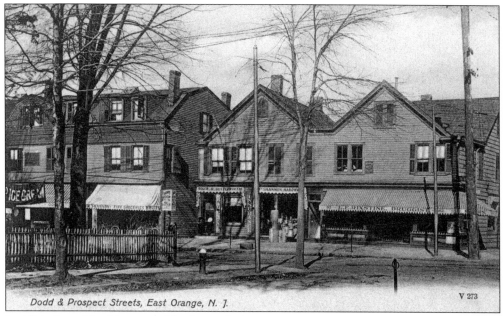

Dodd & Prospect Streets, East Orange, N. J.

In 1678, Daniel Dodd surveyed for himself a large parcel of land near the Watsessing Plain and settled there with his sons Stephen, John, and Dorcas. This view shows the northwest corner of Dodd and Prospect Streets. The building housing Roger H. Butterworth and Shannon Hardware was the original Butterworth's Grocery, built in 1858. Rixtine's also served as post office substation No. 2.

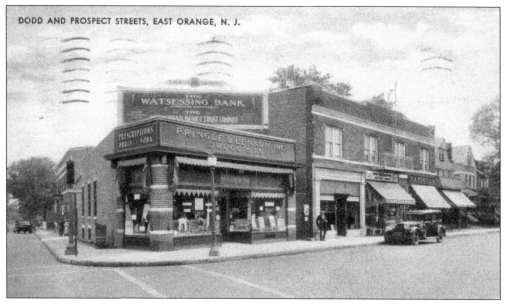

DODD AND PROSPECT STREETS, EAST ORANGE, N. J.

In 1679, John Dodd built a home on the northeast corner of what would become Dodd Street and Midland Avenue. In 1720, copper was discovered on Dodd's property, an area called Rattlesnake Plain. The discovery brought new residents to the area. The mine was located on the north side of Dodd Street, east of what is now Brighton Avenue. It operated until 1760. This view shows the northeast corner of Dodd and Prospect Streets.

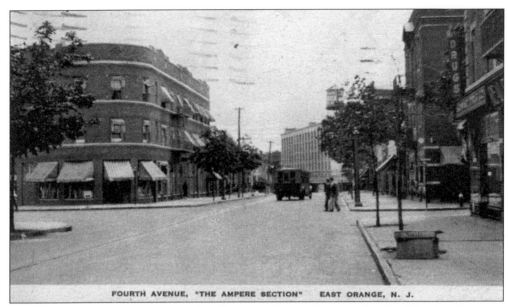

FOURTH AVENUE, "THE AMPERE SECTION" EAST ORANGE, N. J.

The Ampere Section, as mentioned earlier, was born when the Crocker-Wheeler Company arrived. With Crocker-Wheeler came the building of homes for the many people who would work in the factory. Stores and shops quickly followed. This view looks east from the intersection of North Eighteenth Street. Sixty-seven North Eighteenth Street, across from the drug store, housed the first Ampere Library. The large white building in the center is the Ward Baking Company.

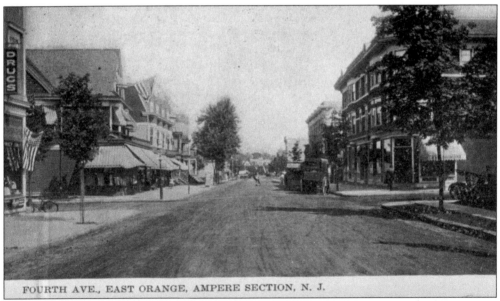

FOURTH AVE., EAST ORANGE, AMPERE SECTION, N. J.

This view also looks east, but was taken from North Nineteenth Street. The Ampere Section was practically a city by itself. It had a bank, post office, train station, movie theater, and a variety of stores supplying food and sundries. Its unofficial boundaries were west of the Newark border, east of North Grove Street, south of Springdale Avenue, and north of Park Avenue. Most people, though, consider the fifth ward, which lies north of William Street and South of North Arlington Avenue, to be Ampere.

Eight
HOMES

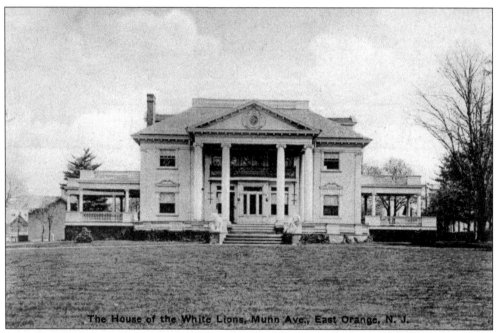

The House of the White Lions, Munn Ave., East Orange, N. J.

The true charm of East Orange was always found in its homes. By the turn of the century, East Orange had numerous mansions lining Munn Avenue, Harrison Street, Arlington Avenue, and other streets. As the wealthy estate holders looked for less crowded towns in which to live, these mansions were replaced by apartment buildings. The automobile made such moves viable. Today, only a few mansions remain. The House of the White Lyons was typical of the Munn Avenue mansions. The author was unable to find conclusive evidence, but believes that this was the home of Mr. and Mrs. Winthrop E. Scarritt at 44 South Munn Avenue. If so, then this later became the Elks Home. The property was 200 feet wide and extended back more than 600 feet to the parkway. Mrs. Scarritt was the president of the Women's Club of Orange.

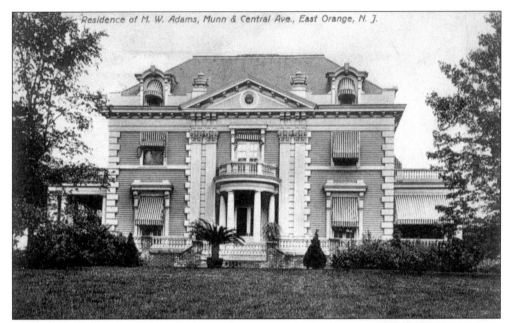

Marcus Whitfield Adams was born in Newark in 1839 and died in Chatham in 1913. He started in the fruit business, became a jeweler, and finally found his niche in insurance. He founded the Sun Life Insurance Company of Louisville, Kentucky, eventually selling the firm to the Metropolitan Life Insurance Company. This residence was at 86 South Munn Avenue, on the northeast corner of South Munn and Central Avenues.

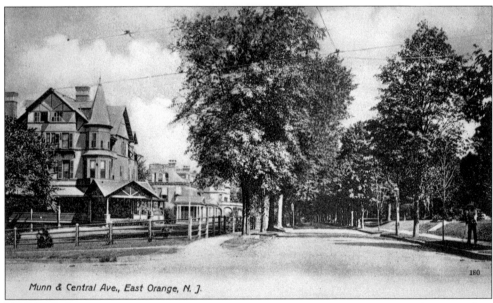

Munn & Central Ave., East Orange, N. J.

The first house on the left, 93 South Munn Avenue, was owned by Mr. and Mrs. William H. Baker. It was located on the northwest corner of South Munn and Central Avenues. Baker was most likely in the iron business. Today, the East Orange General Hospital stands on this spot. The second house, No. 87, was owned by Mr. and Mrs. Joseph H. Chapman. Chapman was in the marine insurance building. The house is still standing and used by the hospital.

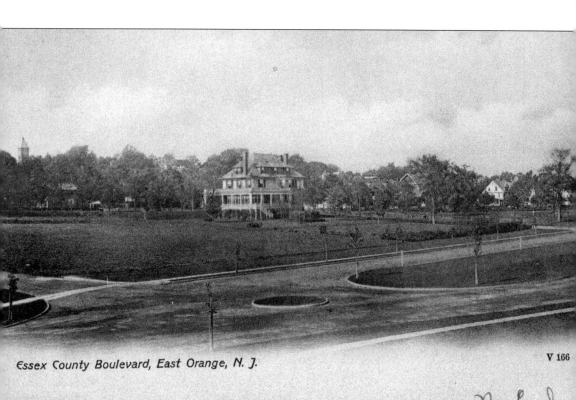

Essex County Boulevard, East Orange, N. J.

V 166

This house, which fronts on North Munn Avenue, was owned by Frederick M. Shepard; however, he lived a few blocks south at 22 North Munn Avenue. Essex County Boulevard was another name for the (Oraton) Parkway. The street on the left is Arlington Place. Running parallel to Arlington Place, just visible at the right edge of the postcard, is New Street. The tower in the distance is East Orange High School.

Shepard may have been the single most important person in East Orange history. He first came to East Orange in 1868 and made the town his year long residence in 1873. Shepard was the founder of the Union India Rubber Company and, with Joseph Albert Minott (who lived on Arlington Avenue), founded the Goodyear Rubber Company. He was a major stock subscriber and president of the Orange Water Company. Shepard was a major contributor to the erection of the Commonwealth Building. He organized the East Orange Safe Deposit and Trust Company and helped to organize the East Orange National Bank. A trustee of the Munn Avenue Presbyterian Church, Shepard helped to build the Elmwood Presbyterian Church. Finally, he was president of the board of trustees of the Carnegie Library. Shepard deeded a 250-foot-wide strip of his own land running north and south for the construction of the Essex County Boulevard.

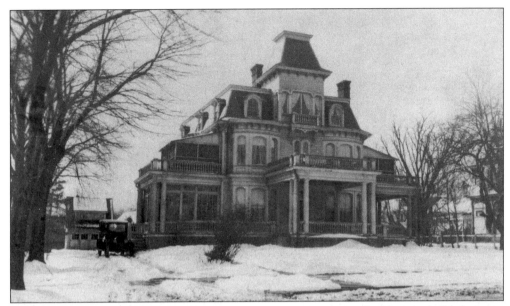

This home at 63 East Park Street was owned by Charles Capron Marsh. The Marsh family is one of the oldest in New Jersey, with roots in Rahway. Marsh was a graduate of Columbia Law School and an attorney with Marsh and Wever at 2 Wall Street in New York. He had a summer home at 185 St. Georges Avenue, Rahway, and another at Popham Beach, Maine. This house no longer stands.

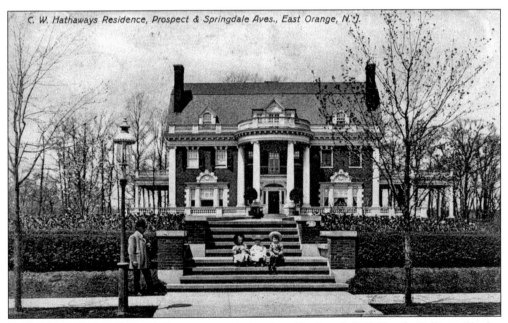

The building in this photograph was seen previously as Kenbrook Hall, Upsala College. Charles W. Hathaway was an organizer of the East Orange National Bank and a director of the Savings Investment and Trust Company. He was the first president of the Riding and Driving Club of Orange. Hathaway was a banker and worked at 45 Wall Street, New York. This house was located at 155 Prospect Street. The lot was 300 feet wide and stretched back to Glenwood Avenue.

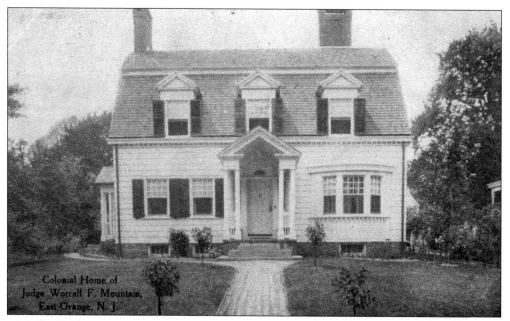

Colonial Home of
Judge Worrall F. Mountain,
East Orange, N. J.

Worrall F. Mountain was born in 1877. An attorney, he was appointed to the bench by Governor
Fort to be a judge of the East Orange District Court in June 1909. Mountain was elected mayor
of East Orange and served in that capacity from 1915 to 1917. Afterward, he served as a circuit
judge in the Essex County Courthouse. This house was later converted to an apartment building.

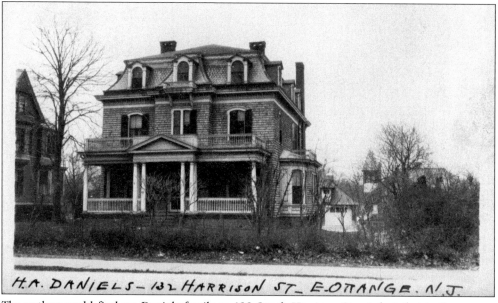

H. A. DANIELS – 132 HARRISON ST. E. ORANGE. N. J.

The author could find no Daniels family at 132 South Harrison Street, but that is the correct
address. The number is barely visible on the third pillar from the left. The steeple visible to the
right of the house is the Sanford Street Methodist Episcopal Church. This house was located on
the east side of South Harrison Street just south of Central Avenue.

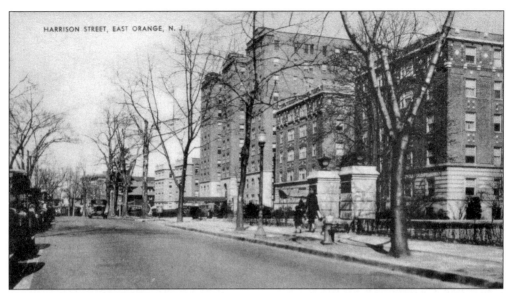

This view looks north toward Main Street. The two stone columns, where the woman and girl are walking, mark the entrance to 132 (formerly 92) South Harrison Street. This mansion was once owned by Edgar B. Ward, a founder of the Prudential Insurance Company. In 1925, it became the W.N. Knapp & Sons Funeral Home. Today it is the Black United Fund of New Jersey. The three large apartment buildings in the center of the photograph are the Fulton Towers.

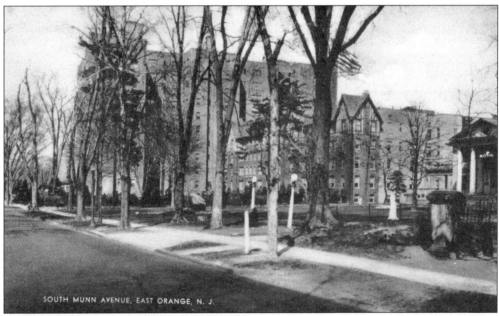

The first apartment building in East Orange was the Hamilton. Constructed in 1911 on the southeast corner of South Munn and Central Avenues, it cost $85,000. It had open fireplaces, timbered dining rooms, doormen, and a restaurant. By the time this photograph was taken, the rows of apartment buildings on South Munn Avenue were nicknamed "the Ivory Coast." This view looks north toward Chestnut Street. The building on the right with the columns is the Elks Home.

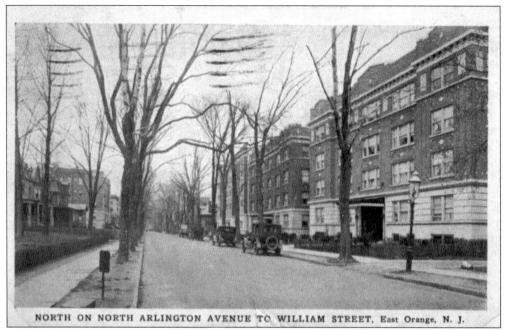

NORTH ON NORTH ARLINGTON AVENUE TO WILLIAM STREET, East Orange, N. J.

From 1911 to 1920, apartment buildings went up on South Harrison Street, South Munn Avenue, Park Avenue, and North and South Grove Streets. After World War I, the East Orange population boomed. Apartments dominated the plans of builders who ran out of space. Older residents complained and zoning laws set aside single family tracts in the first and fifth wards, but many of the main thoroughfares were left open. By the mid-1930s, East Orange had more apartments than any community of its size on the East Coast.

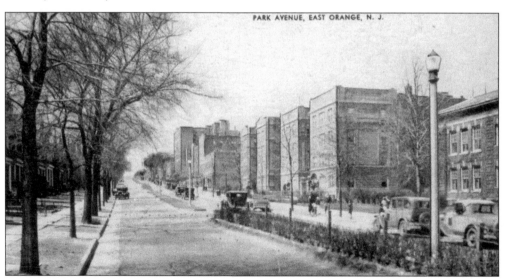

PARK AVENUE, EAST ORANGE, N. J.

Park Avenue was one of the thoroughfares left open. Thirty percent of the city's dwellings were apartments by 1937, and a big apartment-building boom came after World War II. Ninety-six apartments went up in the 1940s. By 1950, 40 percent of the residents lived in the city's 370 apartment buildings. The trend continued into the 1960s. This view looks west from North Clinton Street. The building on the far right is Ashland School.

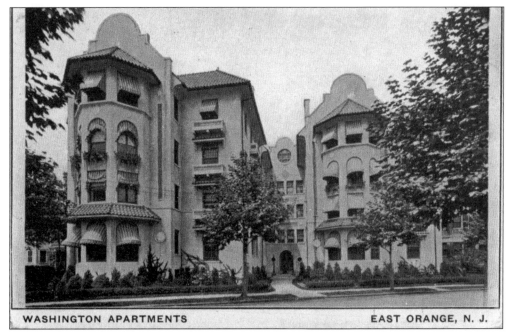

WASHINGTON APARTMENTS EAST ORANGE, N. J.

Not all of the East Orange apartment buildings were multi-storied. Many were garden apartments or elaborately constructed buildings such as this one. The Washington Apartments were located at 31 Washington Street on the northwest corner of Washington and Essex Streets.

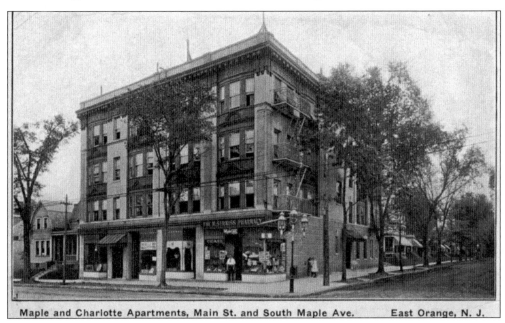

Maple and Charlotte Apartments, Main St. and South Maple Ave. East Orange, N. J.

Many of the East Orange apartment buildings were built on corners and housed multiple stores. The Maple was at 2 South Maple Avenue (right). The Charlotte was at 175 Main Street. Strauss Pharmacy, at 179 Main Street, was owned by Moses Strauss. This view looks south. The building was on the southwest corner of Main Street and South Maple Avenue. It was displaced by Route 280.

94

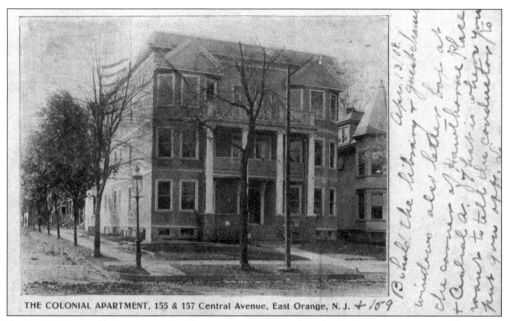

THE COLONIAL APARTMENT, 155 & 157 Central Avenue, East Orange, N. J. + /5⁻9

Typical of the small apartments that began to spring up after the trolleys came to Central Avenue, the Colonial Apartment Building was located on the corner of Hawthorne Place (left). It housed six families. This view looks south. The Cemetery of the Holy Sepulchre is just out of view to the left. The Colonial marked the northeast corner of Hyde Park.

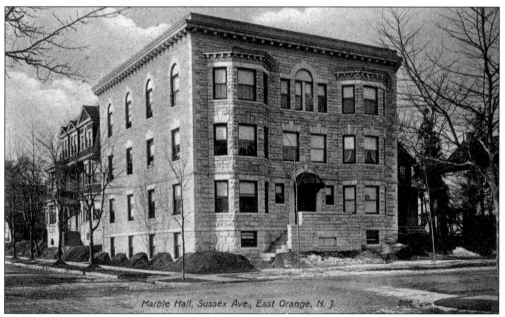

Marble Hall, Sussex Ave., East Orange, N. J.

Marble Hall, at 83 Sussex Avenue, was also a small apartment building. The 1914 city directory shows seven families living there. Like most East Orange locations, it was close to transportation: one block away from the Main Street trolley line, two blocks away from the Grove Street Station. This view looks south. Sussex Avenue is the cross street, and Hollywood Avenue can be seen on the left.

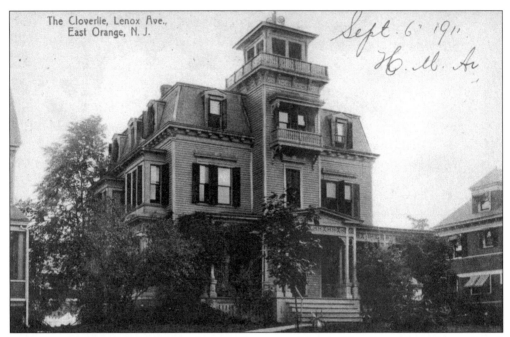

*Sept. 6' 191'.
H. M. A.*

Many East Orange residents lived in boardinghouses and hotels. The Cloverlie was located at 75 Orange Street (Lenox Avenue) at the sound end of South Walnut Street. It was listed in the city directories as the Cloverlie House. Owned by the Blackwell family, the Cloverlie House was later renamed the Lenox Manor.

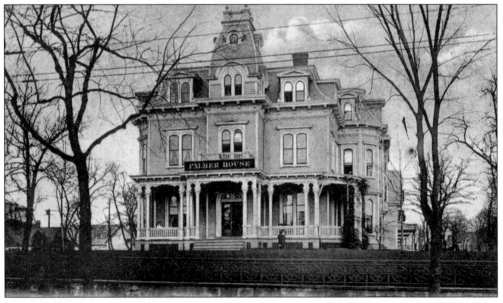

The Palmer House was located at 182 Main Street. A circular driveway, not visible in this photograph, allowed for easy delivery of guests to the front door. This view looks north. The row of trees on the right line North Maple Avenue. Both the small building to the left and the house visible to the right of the hotel are probably those of Frederick W. Pennoyer, the hotel's proprietor and father of Adm. Frederick W. Pennoyer Jr.

Nine
STREETS

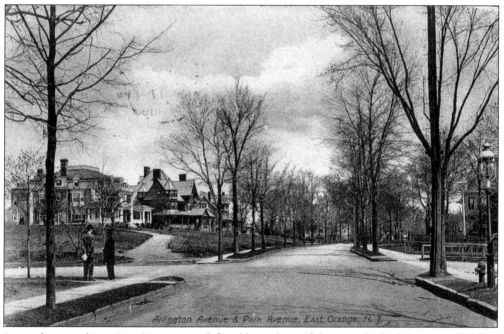

Arlington Avenue & Park Avenue, East Orange, N. J.

As much as anything, East Orange was defined by its beautiful, tranquil, shaded streets. Winding throughout the city were miles of roads lined with pristine homes and towering trees. Manicured lawns, wrap-around porches, and Victorian turrets combined to create elegance and grace. Bowler hats, bustled skirts, and parasols complete these images of a bygone era. This view looks north on North Arlington Avenue. Park Avenue is the cross street. The land on the left belonged to Frederick M. Shepard. The first house on the left belonged to Jonathan T. Rockwell. The Shepards and Rockwells were related through marriage. Johnathan T. Rockwell was a descendant of the Pilgrims. He erected this home in the early 1880s. He was a director of the Orange Water Company and the East Orange Safe Deposit and Trust Company.

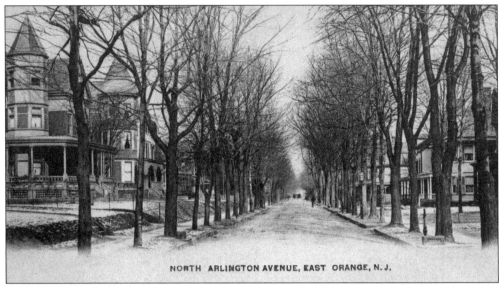

NORTH ARLINGTON AVENUE, EAST ORANGE, N. J.

North Arlington Avenue was originally called Pluck Street and later Cherry Street. This view looks north from William Street. The author believes that the first home on the left was that of Judge Franklin Fort, who was governor of New Jersey from 1908 to 1911 and an associate justice of the Supreme Court of New Jersey. The second home on the left was owned by Mrs. J.C. Osborne, followed by the estate of William H. Rockfellow.

Amherst Street, East Orange, N. J.

Amherst Street originally ran between Central Avenue and the DL&W Railroad tracks. Later, it was extended south to Elmwood Avenue. Eventually, the section of Norwood Street located between Tremont and Elmwood Avenues was also renamed Amherst Street. Amherst Street was named after the college, as were Princeton, Harvard, and Cambridge Streets.

AMPERE PARKWAY EAST ORANGE, N. J.

Ampere Parkway, like the section of town, was named for Andre Marie Ampere. At the turn of the century, all of this land was owned by the Orange Water Company. Water came from the Boiling Spring, which was situated on Grove Street, close to the Bloomfield border. Several wells were drilled, the largest being 100 feet in diameter. The pumping station was located about where Warwick Street and Sawyer Avenue meet today.

Chestnut Street West of Arlington Ave., East Orange N. J.

Like many towns, East Orange has a section of streets named after trees. Beech, Birchwood, Chestnut, Evergreen, Laurel, Linden, Maple, Oak, Olive, Walnut, and Willow were all so named. This view of Chestnut Street looks west to Burnet Street. North Burnet Street was originally called Mulford Street, after a blacksmith shop. It was renamed after the Burnet family, who had real estate holdings in the area.

Carnegie Ave. West of Shepard Ave.
East Orange N. J

This postcard should actually read "Carnegie Avenue west of Nassau Place." Nassau Place is the street on the left. Shepard Avenue is the next street and is indicated by the large trees that appear to be in the middle of the road. These are the Seven Oaks. This area was developed by Frank Coolbaugh, who named the street for Andrew Carnegie, a man he admired.

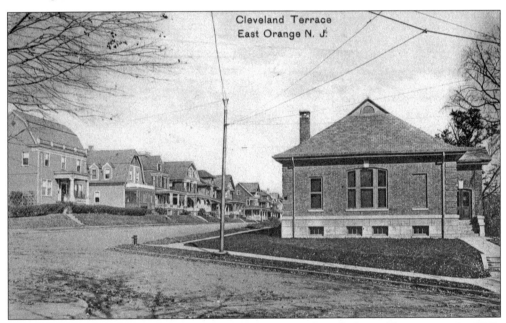

Cleveland Terrace
East Orange N. J.

Cleveland Terrace, in the Doddtown section, was originally called Franklin Avenue. In 1870, developers wanted to change the area nickname from "Doddtown" to "Orange Dale." The land around this area was developed by Charles A. Lighthipe, a real estate agent. This view looks north on Cleveland Terrace. The building on the right is the Franklin Branch of the public library.

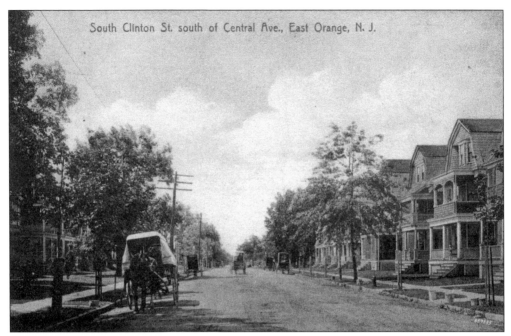

South Clinton St. south of Central Ave., East Orange, N. J.

Unlike North Clinton Street, South Clinton Street was never called Mulberry Street. Clinton Street was possibly named after DeWitt Clinton, the former governor of New York and advocate of the Erie Canal. Much of the land on the left side of this photograph was originally owned by the Trippe family.

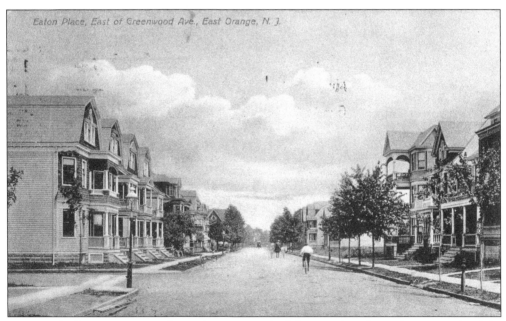

Eaton Place, East of Greenwood Ave., East Orange, N. J.

This view looks east on Eaton Place. The street on the left is North Eighteenth Street. Behind the houses on the right are the DL&W Railroad tracks. Most of the land on which these houses were built was once owned by G.L. Mitchell. The first few houses on both sides of the street look almost identical today.

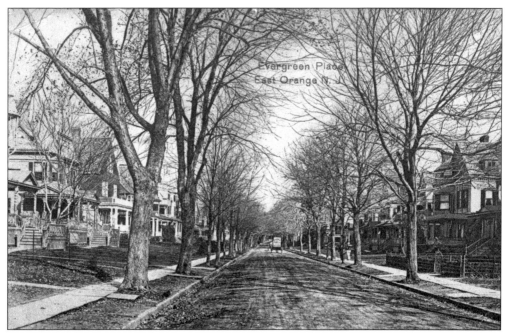

This Evergreen Place photograph was taken looking north from Central Avenue. The wagon in the center of the road is a dairy cart from the Alderney Dairy Company. At one time, people bought milk tickets, which were then used to pay the milkman. The milkman would use a dipper to pour milk into pitchers at each household.

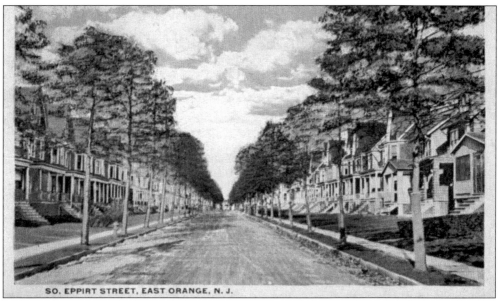

SO. EPPIRT STREET, EAST ORANGE, N. J.

It was perhaps for reasons of modesty that they reversed the spelling of the name, but Eppirt Street is named after the Trippe family. The Trippe family once owned much of the land in this area. This view seems to be looking north from Elmwood Avenue toward Central Avenue. One source states that this area was called "Huckleberry Swamp." Another source reports that Annie Oakely lived at 22 Eppirit Street after being severely injured in a 1901 train wreck.

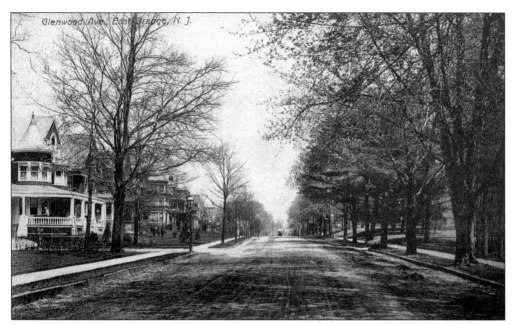

This view looks north on Glenwood Avenue. The street on the left is Park Street, which would eventually pass all the way through Glenwood Avenue and be renamed Eastwood Street. The area on the right between Glenwood Avenue and Prospect Street was once full of quicksand and the source of Bull Spring. Between Main and Washington Streets, Glenwood Avenue was once called Patterson Street, after William Patterson, who owned the property. Glenwood Avenue was opened by George W. Thorpe in 1867.

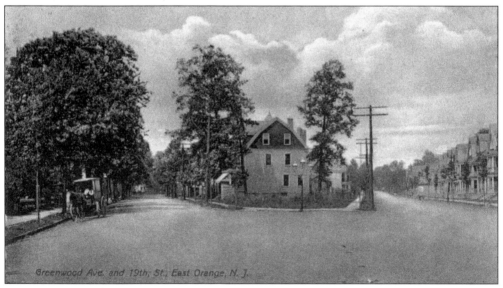

The telephone poles on the right must have been temporary, because unlike the surrounding towns East Orange began placing all its wires underground in 1892. This view looks north. Greenwood Avenue is on the left, and Nineteenth Street is on the right. The steeple barely visible over the top of the house in the center is from Stockton School. The house itself was owned by William P. Bischoff, an electrical engineer.

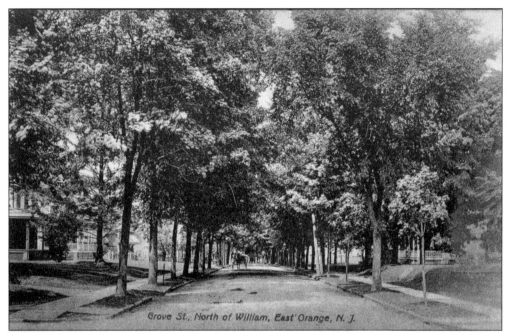

Grove St., North of William, East Orange, N. J.

Grove Street was originally called Whiskey Lane. Jonathan Sayre, a Newark merchant, feared for the safety of his apple whiskey in the presence of so many roving British troops and hid it in Caleb Baldwin's barn. The barn was located on what would later become Grove Street. Hessian soldiers on a foraging trip made camp in the area and happened upon the whiskey, consuming large quantities of it. Local citizens carried off the remaining whiskey, and so the lane was named.

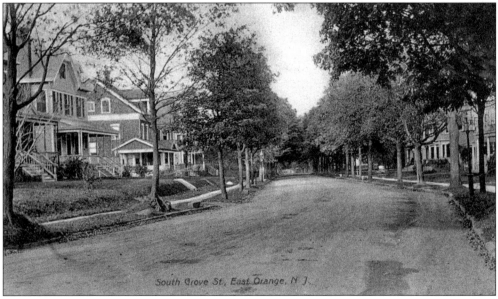

South Grove St, East Orange, N J.

Capt. Frederick Reimer, a seaman and strong temperance advocate, is credited with changing the name "Whiskey Lane" to Grove Street c. 1850. He lettered "Grove Street" on a board and nailed it to a sycamore tree at the intersection with Main Street. This view looks north from Central Avenue from about where Ashland Place is located.

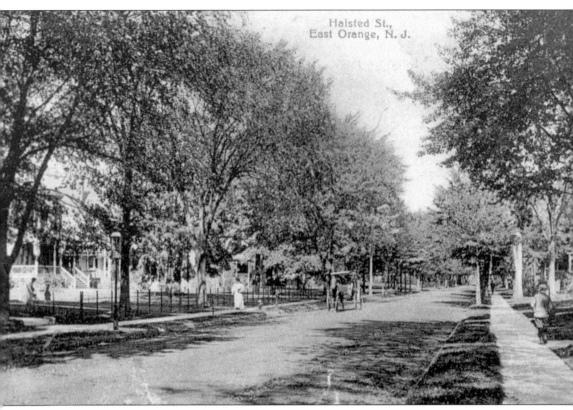

Halsted Street was named for Matthias Ogden Halsted, who graduated from Princeton College and studied law. He left his law practice and entered Halsted, Haines & Company of New York as a partner. One of the stores debtors, Amos W. Condit, offered his 100-acre farm on Main Street in payment. Halsted assumed the debt on his own account and took the farm. He moved to East Orange in 1838 and built a mansion with Corinthian pillars on Main Street in 1840. The farm was located between Halsted and Clinton Streets, stretching south almost to the South Orange border. Halsted later bought another 30 acres adjoining his property on Harrison Street and divided his land into large building plots. He began to erect houses for sale to his New York friends. Halsted took the DL&W Railroad to and from New York. There was no station, so the train picked him up near his residence. In gratitude, Halsted erected a depot on the present site of the Brick Church Station, placed a husband and wife in charge, and gave the station to the railroad. This view probably looks north from Central Avenue.

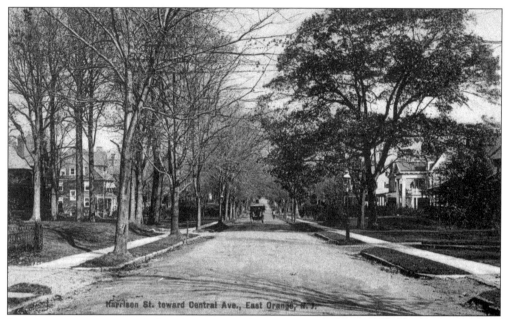

Harrison Street was named after the Harrison family. Sergeant Richard Harrison was a signer of the Fundamental Agreement in 1666. His grandson, Samuel Harrison, settled in Orange on Washington Street, about 200 yards west of Day Street. Nathaniel Harrison (1705–1779) owned a farm located on the ridge through which Harrison Street now runs. This view looks north from East Highland Avenue. The wrought-iron fence on the left marks the entrance to the Francis E. Johnson estate.

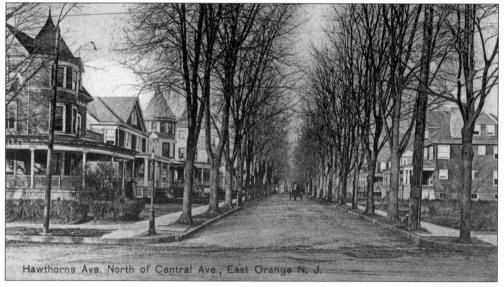

Like the "tree streets," East Orange also has a cluster of streets named after authors, including Emerson, Whittier, and Irving. Hawthorne Avenue was probably named for Nathaniel Hawthorne. However, one source reports Hawthorne to be a tree street, named after the hawthorn tree. August Hahne, of Hahne & Company of Newark (the department store), lived in the first house on the right.

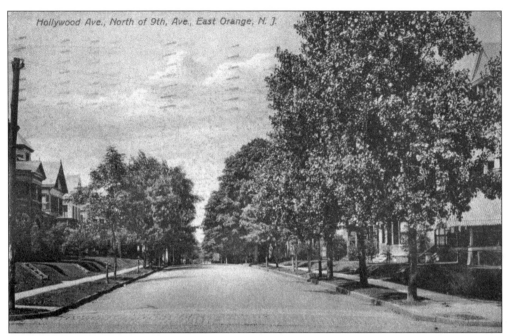

Hollywood Avenue was first called Pulaski Street after Casimir Pulaski, the Revolutionary War general from Poland who was killed in 1779 during the siege of Savannah. Originally, Hollywood Avenue ran straight through to Main Street, but today it ends at Winthrop Terrace. Winthrop Terrace, named after Dr. Winthop D. Mitchell, ended at South Grove Street at the time this photograph was taken. Eventually, Winthrop Terrace was extended to Steuben Street.

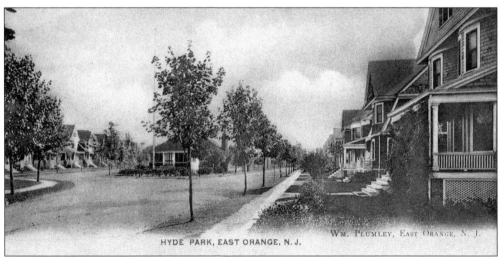

HYDE PARK, EAST ORANGE, N. J.

WM. PLUMLEY, EAST ORANGE, N. J.

Hyde Park was developed by Watson Whittlesey on land that had been the farm of James Peck. The Peck family was one of the founding families of 1666. Pecktown, the area near Main Street bordered by Arlington and Maple Avenues, is named for the Peck family. This view looks south. Wilcox Place is on the left, and Whittlesey Avenue is on the right. The Hyde Park Clubhouse is just to the left of center.

Lenox Avenue was originally named Orange Street. This view looks east. South Walnut Street is visible just past the sixth tree on the left. The street at the end of the second block is South Arlington Avenue.

This view looks north to Main Street. Originally called Maple Avenue, the section north of Main Street was called Mechanic Street. A small Revolutionary War battle was fought at Peck Hill, located near the intersection of Maple Avenue and Main Street. John Wright, John Tichenor, and Joshua Shaw engaged three Highlanders. The British fled, but not before Wright was seriously injured. Lincoln School is out of view on the right.

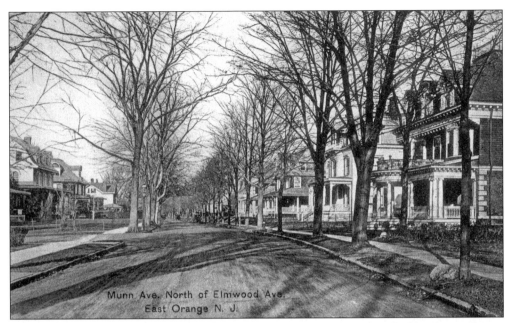

Munn Avenue is named for the Munn family. John Mun was probably the first family member to settle in East Orange. His son Benjamin owned a farm on Mun Lane, which was later renamed Munn Avenue. Their farmhouse was located on the corner of South Arlington Avenue and Main Street. This view looks toward Central Avenue. The houses on the right remain, but apartment buildings line the left side of the street.

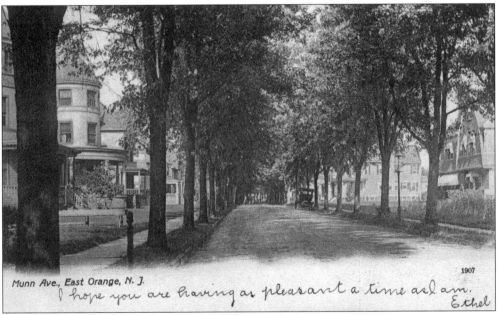

This photograph was probably taken looking south from Elmwood Avenue. The first house on the left, 126 South Munn Avenue, may have been that of Fred A. Reimer, who was the assistant city engineer. The second house, No. 130, was most likely that of William Peck, a descendent of Henry Peck, who was one of the signers of the Fundamental Agreement.

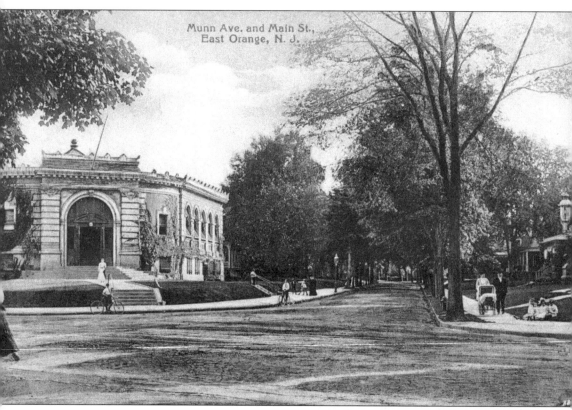

Munn Ave. and Main St.,
East Orange, N. J.

Benjamin Munn's son, David, inherited the 150-acre Munn farm. David was a member of the Essex County Militia during the Revolutionary War. Joseph Lewis Munn, the great-great-grandson of John Mun, was a graduate of Princeton and an attorney. He was the trustee of the East Orange public schools for over 30 years and president of the board of education. He was called "the father of Eastern School." In January 1878, Munn's house was connected by telephone to the lecture room of the Junction Church (probably the Munn Avenue Presbyterian Church). It was the first telephone in East Orange. This view looks south on Munn Avenue. Main Street is the cross street. The Carnegie Library is on the left. The stone building on the right is the Munn Avenue Presbyterian Church. The first home past the church was that of Joseph L. Munn. There were more than a dozen mansions along Munn Avenue. Some estates had names, such as the Walton's "the Beeches," the Hill's "Hillcrest," and the Freeman's "Elm Gate."

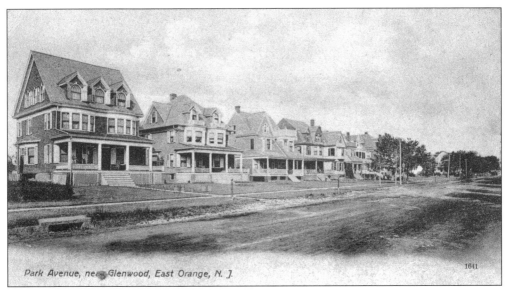

Park Avenue, near Glenwood, East Orange, N. J.

1641

The town committee turned Park Avenue over to the control of the Essex County Park Commission on April 12, 1897. The avenue was preserved for pleasure driving. Shrubberies were planted in the center of the roadway, and all vehicular traffic except for passenger transit was outlawed. This view looks west from Glenwood Avenue.

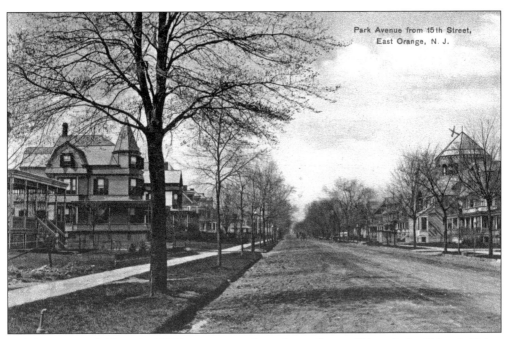

Park Avenue from 15th Street, East Orange, N. J.

Park Avenue was laid out in 1871 by county engineer James Owen. Although the Citizen's Union was unable to keep the trolleys off of Central Avenue, the Park Avenue Association of East Orange was more successful, and trolleys never ran on that street. However, the 1921 zoning ordinance left Park Avenue open for apartment buildings. This view looks west. The cross street is North Sixteenth Street. On the right is the Disciples of Christ Church.

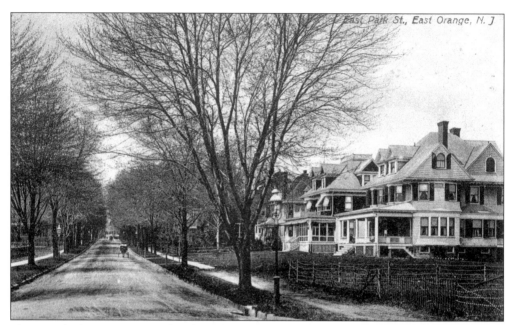

This view looks west. It was taken from the intersection of Midland Avenue (right), Park Street (left—later Eastwood Street), and East Park Street (straight). The stone wall on the far, lower left marks the property of Charles A. Sterling. This would later become the exercise field of East Orange Catholic High School. The field on the right was owned by Anna Thorpe, the first house by Ellen Gates, and the second by Alfred Taft. Taft was a silk importer.

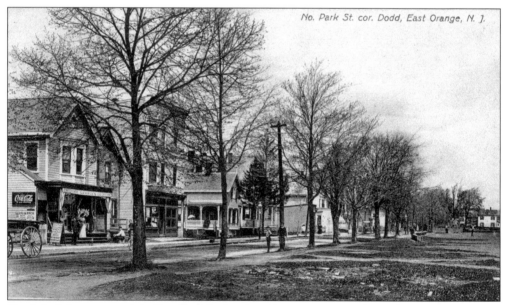

North Park Street was originally called the Road to Cranetown (Montclair). This view looks north on North Park Street. The store on the left is Gamble's Ice Cream. On the side of the building, a sign advertises R. Walsh & Company ice cream. The sandwich sign is selling Smith bread, pies, cake, and milk by the quart, pint, or glass. In 1926, the first traffic light in East Orange was erected at this intersection.

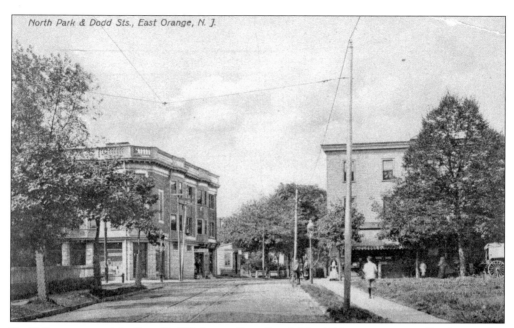

Dodd Street was originally called Nishyune Ferry Road. The Nishyune was a small tributary that joined Perro Brook to form the Second River. There was no "ferry," probably just some floating logs or a crudely constructed crossing. This view looks west on Dodd Street. On the right is the Charles E. Menagh Pharmacy. Menagh's housed a post office substation. On the left is a meat market, probably owned by Isidore Bachman.

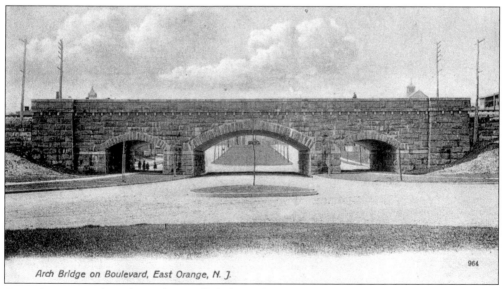

964

Arch Bridge on Boulevard, East Orange, N. J.

Essex County Boulevard was later called the Parkway, the East Orange Parkway, and Oraton Parkway. This view looks south from New Street. The archway shown carries the DL&W Railroad tracks. The steeple on the left is the First Baptist Church. The steeple on the right is probably the First Presbyterian Church. Business vehicles were not allowed on the Parkway.

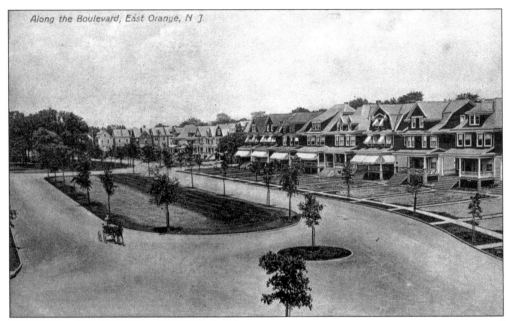

This photograph was taken from the archway looking northeast toward New Street. Several photographs of this scene seem to indicate that trotters were once exercised at this location. Oraton Parkway was named for Oraton, chief of the Hackensack Native Americans at the time of the arrival of the first European settlers in Newark. This bucolic scene was displaced by the Garden State Parkway.

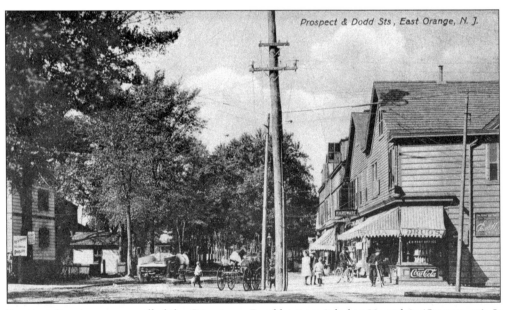

Prospect & Dodd Sts, East Orange, N. J.

Prospect Street was once called the Cranetown Road because it led to Montclair (Cranetown). It was also called Doddtown Road. This view looks south on Prospect Street. Dodd Street is visible on the right. It was at this location that the Crosstown Trolley turned off Dodd Street and headed north on Prospect Street. The building on the right, 245 Prospect Street, housed a post office substation. The sign for the post office is visible in the window over the Coca-Cola advertisement.

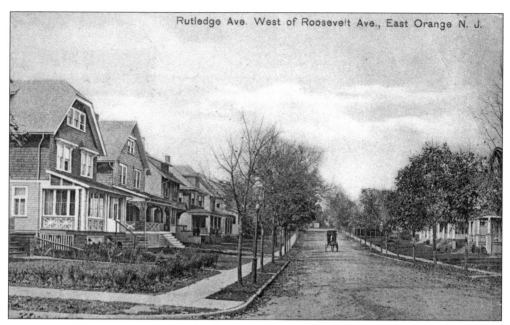

In the early 1900s, the land on which Roosevelt Avenue was built was owned by the Orange Water Company. Several East Orange Streets were named after presidents, including Grant, Madison, Monroe, and (Teddy) Roosevelt Avenues; Lincoln and Washington Streets; and Cleveland Terrace and Garfield Place. Rutledge Avenue may have been named after Edward Rutledge. This view looks west.

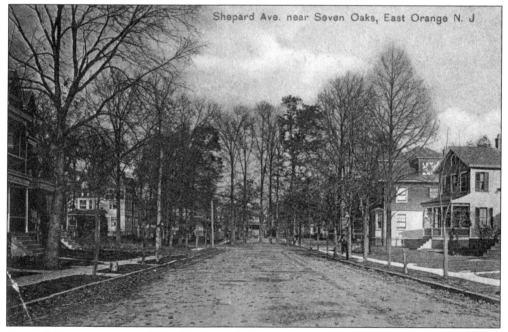

Shepard Avenue was named for the Shepard family. The name Seven Oaks refers to the trees located on the island in the center of the photograph. The cross street at that island is Carnegie Avenue. The house visible at the end of Shepard Avenue is on Beech Street.

Seven Oaks, Harrison Ave., East Orange, N. J.

Postcard publishers and their photographers did not always correctly identify their sites. Seven Oaks was not on Harrison Avenue. This view looks north on Shepard Avenue; the cross street is Carnegie Avenue. The island is still there, but the oak trees are gone.

Springdale Ave. West of Grove Street, East Orange N. J.

Springdale Avenue was once called Forest Avenue. East of North Grove Street, the road was called Boiling Spring Road. At one time, there was a spring located about where Soverel Field is now, thus giving Springdale Avenue its name. This view looks west on Springdale Avenue. On the right is Arnold Grocers, while on the left is a drug store owned by George S. Male.

Springdale Ave. West of Midland Ave., East Orange, N. J.

The home of John Wright was located west of this intersection. British soldiers raided his farm and slew 18 of his geese, leaving this note: "Dear Mr. Wright, we must bid you goodnight, / It is time for us to wander; / We have paid for your geese a penny apiece, / And left the change with the gander." Eighteen pennies were left in a pouch around the gander's neck. The Wright home was later owned by the Matthias Soverel and was demolished in 1937.

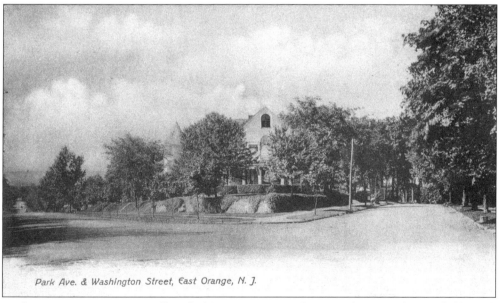

Park Ave. & Washington Street, East Orange, N. J.

Washington Street was originally called Tory Corner Road. It was also named Swinefield Road. The latter name originated from farmers who drove their pigs along this path to Rattlesnake Plain (Doddtown) to feast upon beechnuts—and snakes. The name was changed during the real estate boom of 1836–1837. This view looks west on Park Avenue (left) and north on Washington Street (right). The house shown was owned by Fred R. Hasselman, an architect.

117

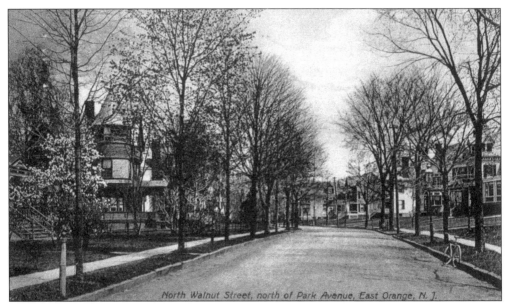

North Walnut Street, north of Park Avenue, East Orange, N. J.

Another "tree street," 91 North Walnut, was the home of Alexander King. King enticed his friend Andrew Carnegie to build the East Orange library. Walnut Street was also home to Charles Renshaw, after whom Renshaw Avenue was named. Gas lamps such as the one on the right were first installed in East Orange in 1872 on Cherry, Harrison, and Washington Streets.

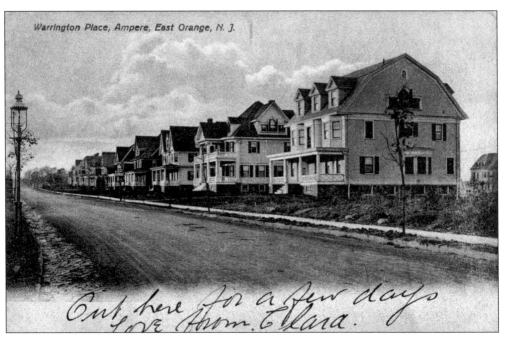

Warrington Place, Ampere, East Orange, N. J.

Most of this land had been owned by the Booth family. Their holdings extended north to Springdale Avenue. At the crest of the hill, on the right, 84 Warrington Place housed the convent of Our Lady of All Souls. The convent was originally owned by John E. Judson, a broker. (The author lived across the street from the convent at No. 85 from 1966 to 1980, making this his favorite postcard in the book.)

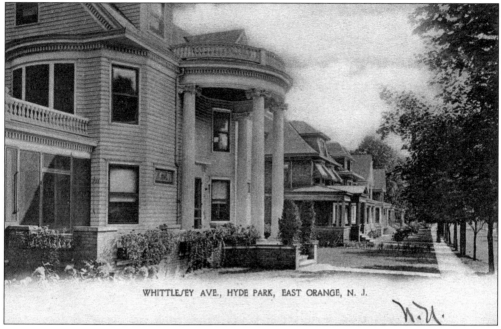

WHITTLE/EY AVE., HYDE PARK, EAST ORANGE, N. J.

This view looks south. The house on the left actually fronted on Central Avenue, not Whittlesey Avenue. Hyde Park was bordered by Central Avenue on the north, Wilcox Place on the south, Hawthorne Place on the east, and Munn Avenue on the west. This street was named for the developer, Watson Whittlesey, whose own residence was at 18 Hawthorne Place.

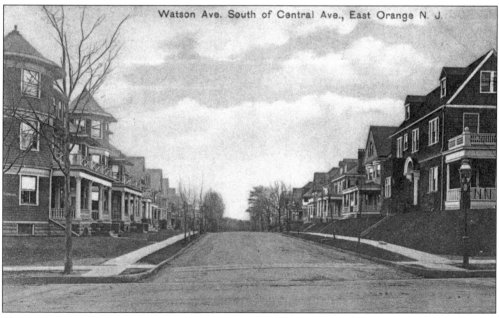

Watson Ave. South of Central Ave., East Orange N. J.

The Hyde Park homes sold from $3,500 to $6,500. Houses were available for 10 percent down and monthly payments of $35 to $65. A small amount to pay for "comfort, convenience, good health and life-long enjoyment." Speculation lots were also sold from $25 to $40 per front foot. Watson Avenue was also named for Watson Whittlesey.

119

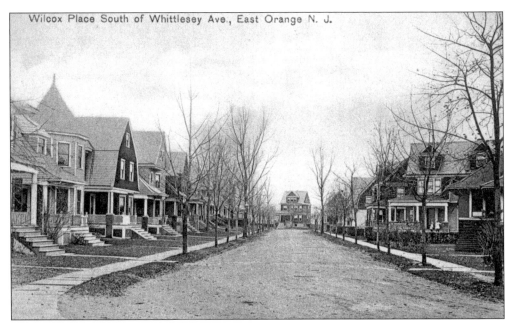

The Hyde Park clubhouse is visible on the right. Hyde Park offered homes on lots 35 feet wide and 100 feet deep. They contained seven to ten rooms. Each house had a cellar. Hyde Park advertised flagged sidewalks, macadamized streets, a 9¢ train fare to New York, and a 5¢ trolley fare to Newark. The Garden State Parkway now runs through where Wilcox Place once was.

Winans Street, North, East Orange, N. J.

Winans Street, which housed East Orange High School, was also home to Richard Coyne (No. 14), a horse fancier and owner of Coynes Stables located on Main Street west of South Arlington Avenue. The street was probably named for the Winans family. They owned the unseen house protected by the fence on the left. This view looks north. The high school is farther down on the left.

120

This popular photograph was taken looking east from North Twenty-first Street. The cross street just visible in the lower center of the postcard is Greenwood Avenue. In December 1903, East Orange formed a Shade Tree Commission. The commission's first tree was planted on October 19, 1904, on the corner of Beech and Burnet Streets. The first forester was William Solataroff, whose book *Shade Trees in Towns and Cities*, published in 1911, was still in use 50 years later. The willows are now gone.

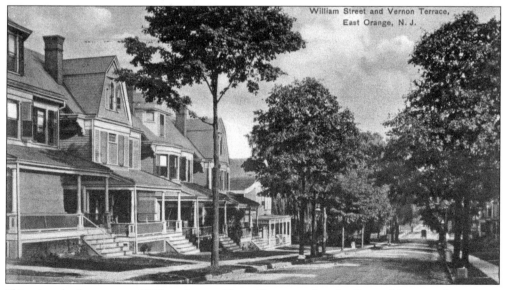

William Street and Vernon Terrace, East Orange, N. J.

This view looks east on William Street. The willows are barely discernible near the wagon. Vernon Terrace is on the left. Author W.E.B. Griffin (William E. Butterworth III) lived on Vernon Terrace as a young boy. William Street could have been named for William King (the first town chairman), Prince William of Orange, or the Williams family. However, no conclusive answer could be found.

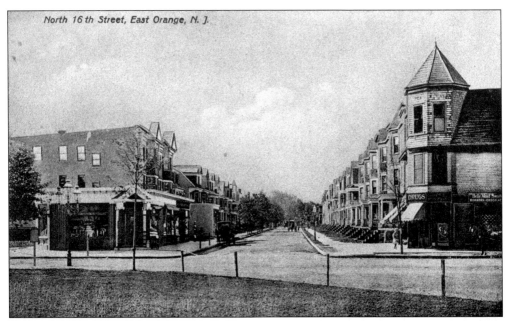

North 16th Street, East Orange, N. J.

Like the "president" streets and "tree" streets, East Orange has a series of "teen" streets. This view looks south on North Sixteenth Street from Fourth Avenue. On the right is one of the several Ampere Pharmacies that existed on Fourth Avenue. The store on the left changed hands several times, too. In this photograph, it is a grocery store owned by J. Oscar Ohlson.

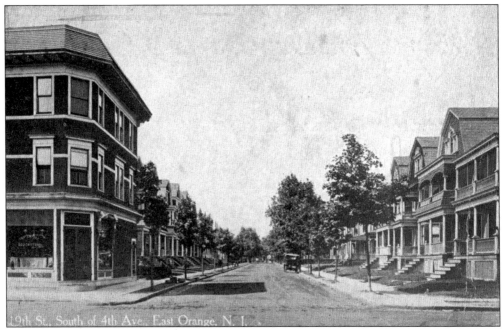

19th St., South of 4th Ave., East Orange, N. J.

This view looks south on North Nineteenth Street toward Park Avenue. On the left is the Ampere Delicatessen. The lots on the "teen" streets were small, most of them about 30 feet wide. These were working-class houses. For example, the eighth house down on the right, No. 185, was the home of H.P. Jones, the agent in the Ampere Station.

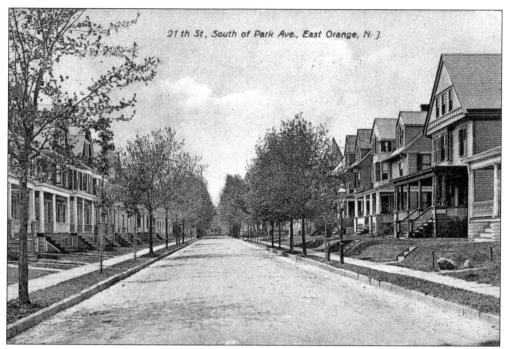

North Twenty-first Street south of Park Avenue is called Stockton Place today. The home at the end of the road is on William Street. Macadamizing of streets started in East Orange in 1869, with the major roads being completed by 1872. Macadamizing is a process of rolling successive layers of small, broken stone into an earth roadbed.

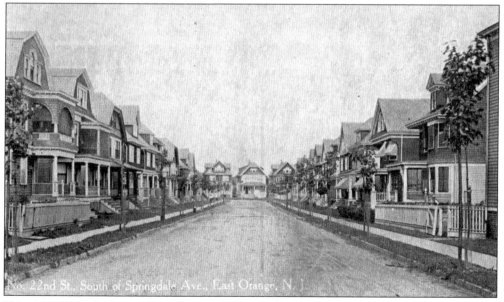

This view of North Twenty-second Street looks south toward Fourth Avenue. Most of this land had been owned by the Booth family before it was subdivided into lots. The message on the back, so simple, conveys the same message as every other postcard in this chapter: "This is a very pretty place."

123

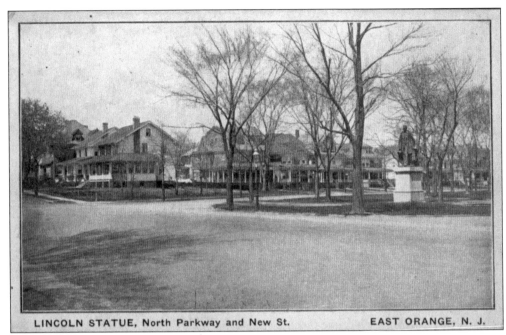

LINCOLN STATUE, North Parkway and New St.　　　　EAST ORANGE, N. J.

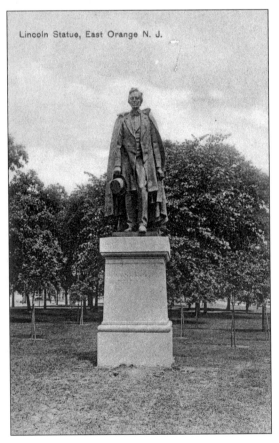

Lincoln Statue, East Orange N. J.

This view looks north on the Parkway from New Street. Ground was broken for the Lincoln Statue on November 19, 1910. It was dedicated on Flag Day, June 14, 1911. On February 12, 1912, Pres. William Howard Taft visited this spot and placed a wreath upon the statue in front of several thousand people, while Battery A honored him with a salute.

The Lincoln Statue was designed by sculptor Frank Edwin Elwell and cost $8,000. Born in 1858, Elwell was first tutored in art by author Louisa May Alcott. He then studied in the Ecole des Beaux Arts in Paris. Made of bronze, this statue was one of more than 50 works by Elwell. The model was William J. Baer. The statue was moved to the city hall after being displaced by the Garden State Parkway.

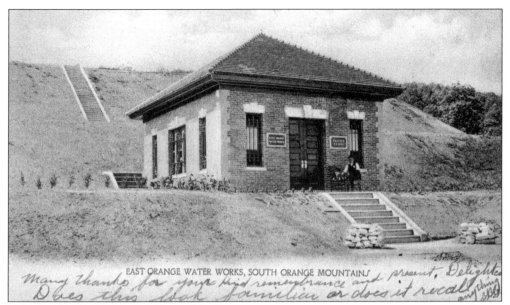

EAST ORANGE WATER WORKS, SOUTH ORANGE MOUNTAINS

Many thanks for your kind remembrance and present. Delighted. Does this look familiar or does it recall anything?

The formation of the East Orange Waterworks allowed for the creation of most of the streets in the northeast corner of the city. The East Orange Water Department was founded on January 1, 1903. Water was discovered and farmland purchased at White Oak Ridge near Millburn. The Boiling Spring area was sold. The water reserve measured 1,854 acres. Many trees planted to protect the location were cut down during World War II for use in making PT boats.

NORTH MUNN AVE. GARAGE, 195 North Munn Ave., East Orange, N. J.

Over the years, this garage housed the telephone company, an ambulance service, and even federal agents. The agents raided local stills. They would give the confiscated sugar and molasses not needed for evidence to Munn Avenue residents—such as the author's parents, who lived across the street.

125

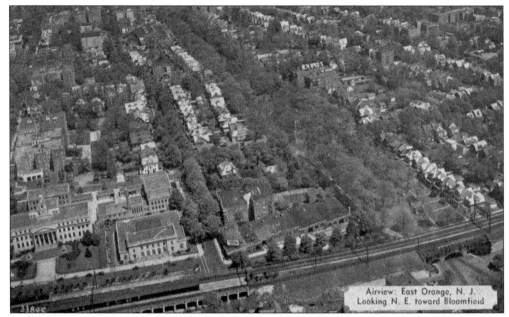

The DL&W Railroad tracks are clearly visible in the foreground of this aerial view. In the lower left of the photograph the city hall, the Health Department building, the police station, and the post office can all be seen. The row of trees in the center would become the location of the Garden State Parkway. The armory is visible in the upper left at the end of the row of trees.

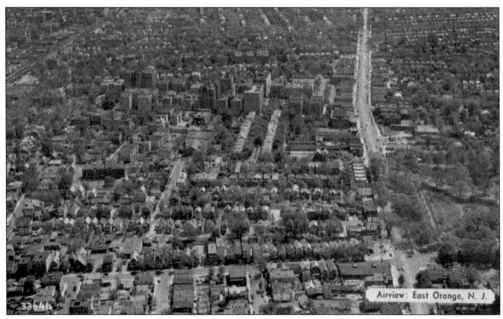

This aerial view looks east. Central Avenue is the wide boulevard in the right portion of the photograph. The crescent-shaped land at the right is Orange Park. Harrison Street intersects Central Avenue where Central Avenue bends slightly to the right. In the upper left corner, you can see the DL&W Railroad tracks.

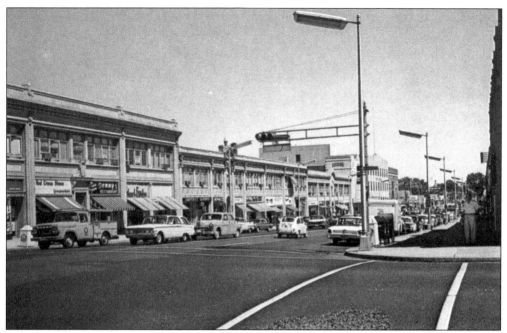

Two wonderful postcards end this book. Together, they bring closure to a story that began as a small farming village. The first looks east on Central Avenue from Harrison Street. The second looks west on Main Street toward Brick Church. In 1938, William Hunter Maxwell wrote a poem entitled "The Soul of East Orange" to commemorate the city's 75th anniversary. The first and last verses are provided below.

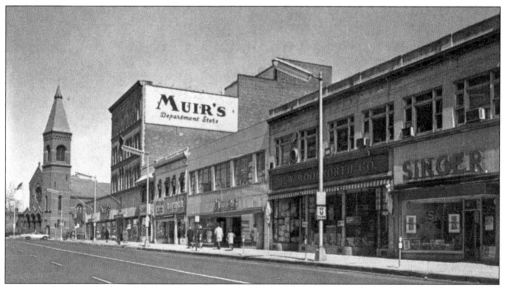

"A stout limb on a sturdy tree, / Proud East Orange has grown to be; / Alluring, happy, and pleasingly mild, / With sheltering branches undefiled, / Admired by neighbors on every side, / And blessed with fame far and wide. . . . // Oh Limb of progress on a sturdy tree, / God's tender blessings be on Thee, / Adored City with the friendly hand, / Beautiful realm on Jersey Land, / Soul of East Orange, under God's sun, / Soul of East Orange, God's Will be done."

BIBLIOGRAPHY

Allmen, Diane C. *The Official Identification and Price Guide to Postcards*. New York: House of Collectibles, 1990.

Byatt, Anthony. *Collecting Picture Postcards: an Introduction*. Malvern, Worcs.: Golden Age Postcard Books, 1982.

Carlson, Cary, Editor-in-Chief. *Upsalite* 1960.

The East Orange Record, The Centennial Edition. Orange, NJ: Worrall Publications, May 2, 1963.

The East Orange Record. Various. Orange, NJ: Worrall Publications, 1942–1943.

Kinney, Kevin. *East Orange Settlement Day*. 1976.

Meehan, Thomas G. *In Lackawanna's Shadow: Erie's Orange Branch*.

Peabody, Robert T., Chairman. *Seventy Fifth Anniversary: the City of East Orange New Jersey*. Orange, NJ: Coyler Printing Company, 1938.

Pierson, David Lawrence. *History of The Oranges to 1921. Vol. I–IV*. New York: Lewis Historical Publishing Company, 1922.

Railroadians. *The Next Station Will Be . . . Erie: Greenwood Lake Division: Orange Branch: Caldwell Branch Vol. III*. A Railroadian Book, 1975.

Riley, John Harrington. *The Newark City Subway Lines*.

Shaw, William H. *History of Essex and Hudson Counties, New Jersey Vol. II*. Philadelphia: Everts & Peck, 1884.

Stuart, Mark A. and Jessie W. Boutillier. *A Centennial History of East Orange*. East Orange Centennial Committee, 1964.

Tabor, Thomas Townsend and Thomas Townsend Tabor III. *The Delaware, Lackawanna & Western Railroad in the Twentieth Century 1899–1960*. Williamsport, PA: Thomas T. Tabor II, 1981.

Vespucci, Richard and Donna Lee Goldberg. *A History of East Orange*. Orange, NJ: Worrall Publications, 1976.

Whittemore, Henry. *The Founders and Builders of the Oranges*. Newark, NJ: L.J. Hardham, Printer and Bookbinder, 1896.

Wickes, Stephen. *History of the Oranges in Essex County, NJ, from 1666 to 1806*. Newark, NJ: Ward & Tichenor, 1892.